INTERSECTIONS

INTER SECTIONS

The Grand Concourse

at 100

ANTONIO SERGIO BESSA

EDITOR

FORDHAM UNIVERSITY PRESS
THE BRONX MUSEUM OF THE ARTS
NEW YORK 2009

Library of Congress Cataloging-in-Publication Data

Intersections: The Grand Concourse at 100 / Antonio Sergio Bessa, editor. — 1st ed.
p. cm.
Includes bibliographical references.
ISBN: 978-0-8232-3078-5 (cloth : alk. paper)
1. Grand Concourse (New York, N.Y.)—History. 2. Grand Concourse (New York, N.Y.)—Anniversaries, etc. 3. Bronx (New York, N.Y.)—History. 4. New York (N.Y.)—History.
5. City planning—New York (State)—New York—History. 6. Architecture—New York (State)—New York—History. I. Bessa, Antonio Sergio.
F128.68.B8I55 2009
974.7'275—dc22
 2009026927

Printed in the United States of America
11 10 09 5 4 3 2 1
First edition

FORDHAM UNIVERSITY PRESS

BRONXUSEUM

INTER
SECTIONS

ACKNOWLEDGMENTS
HOLLY BLOCK

Centennial celebrations are momentous occasions for people, communities, boroughs, and governments to come together. This year marks the 100th anniversary of a majestic boulevard integral to the life of the Bronx that is taken for granted every day—whether one walks, sits, drives, rides the bus, bikes, skateboards, scooters, hails a gypsy cab, rides a helicopter, or flies over the Grand Concourse, its sheer grandeur is often passed unnoticed.

Certainly more forms of transportation exist today than when the beautiful gateway conceived by Louis A. Risse in 1870 opened to the public in 1909. And the boulevard, which originally combined the attributes of beauty and facility with utmost grace, has lost many of the trees it was lined with since its inception—with varieties ranging from pines and elms to hawthorns and oaks. But the very fact that we now celebrate this centennial is proof enough that the Grand Concourse has survived its many detractors and still plays an important role in the borough.

Who could have imagined that President Jimmy Carter's tour of the South Bronx and Howard Cosell's declaration that "the Bronx is burning" at the World Series game in 1977 would produce a stigma of urban blight that hangs over the Bronx to this day? We must recognize that the slow process of development helped maintain a wealth of art deco and art moderne buildings, providing a window to the past that allows us to better plan for the future. These architectural wonders serve as anchors for the Grand Concourse, and, ironically, they still stand as a result of the lack of capital development and urban renewal that has been held back from the borough for many decades.

Our focus with this project has been not only to create awareness about the Grand Concourse and our surroundings but also to celebrate the rich cultural life of our borough. Several other Bronx landmarks are more than a hundred years old: Henry Hudson Park, Macombs Dam Park, Edgehill Church of Spuyten Duyvil, Grace Episcopal Church on City Island, All Hallows High School, St. Catherine High School, Robert Colgate House, the Bronx Zoo, the New York Botanical Garden, Fordham University and Fordham University Press SUNY Maritime College, and the Hall of Fame for Great Americans to name a few.

The Bronx Museum has displayed spectacular foresight in organizing exhibitions devoted to art and architecture of the Bronx. They include *Devastation/Resurrection: The South Bronx* (1980), *Building a Borough: Architecture and Planning in the Bronx, 1890–1940* (1986), *Urban Mythologies: The Bronx Represented since the 1960s* (1999), *One Planet Under a Groove* (2001), and *Street Art, Street Life: From the 1950s to Now* (2008), in addition to a multitude of public programs.

Intersections: The Grand Concourse at 100 celebrates both our family histories of strolling along the Concourse and a future of renewal, when the Concourse can become once again the greenway envisioned by Louis A. Risse. Much of the Bronx is still based on personal exchange, and I cannot imagine more perfect a place to walk than the Grand Concourse on a sunny Sunday. More than merely a celebration of 100 years past, this volume also carries a birthday wish for the next 100 years, by honoring our beautiful boulevard to continue its grandeur.

The Bronx Museum of the Arts, while not yet 40 years old, has been working toward this celebration since 2005 under its former director's initiation. We have created workshops with students, enlisted the help of neighborhood advisory groups, and planned a three-part exhibition entitled *Intersections: The Grand Concourse at 100*, highlighting the past, present, and future of the Grand Concourse. We have collaborated with many individuals, organizations, and city institutions to bring this project to fruition.

Community involvement in this project has been an important goal from the outset. We would be remiss if we did not mention the Salvadori Institute, organizers of our first charrette in 2005 for a group of 100 students from PS/IS 218 Rafael Hernandez Dual Language Magnet School, with an additional 20 high-school students from the Pablo Neruda Academy for Architecture and World Studies serving as mentors. The public charrettes proved to be an enormous success, and the Center for Urban Pedagogy also led two successful workshops in 2007 and 2008 with students from the Bronx High School for the Visual Arts. In 2009, the urban planners Claire Napawan and Gonzalo Cruz also used the structure of the Grand Concourse as an exercise in their classes at City College of CUNY.

We are grateful to all the artists, lenders, and advisors whose efforts and generosity helped to produce this magnificent and important exhibit. We highlight Bronx–resident artist Daniel Hauben, artist and AIM alumna Pia Lindman, and once–Bronx resident artist Aaron Birk, who all contributed with specific works about the borough. In addition, the Bronx Museum commissioned artists Skowmon Hastanan, Pablo Helguera, Acconci Studio, Katie Holten, Jeff Chien-Hsing Liao, and Kabir Carter to produce new works specifically for this centennial celebration.

Lenders to the exhibition included The Museum of Modern Art, New York; The Metropolitan Museum of Art, New York; The Museum of the City of New York; New York Historical Society; The Bronx County Historical Society; William Casari; PaceWildenstein

Gallery and the Adolph and Esther Gottlieb Foundation, New York; Projeto Hélio Oiticica; Diana Gordon; and Randal Wilcox and The Alvin Baltrop Trust. Our advisory team included Ned Kaufman, Joyce Hogi, José Oyola, Dan Donovan, Wilhelm Ronda, Sam Goodman, Ray Bromley, Francis Morrone, Constance Rosenblum, Erin McCluskey, Jessica Sheridan, Darris James, Peter Derrick, Anthony Greene, William Casari, William Menking, James Crocker, Nestor Danyluk, and Brian Purnell among others. We also received inestimable advice and historical material from Pascal Flaus and Sébastien Vion, historians at Saint Avold, France, the birthplace of Louis A. Risse.

We also thank our many partners: Dr. Gary Hermalyn at the Bronx County Historical Society; Deborah Marton, Stephanie Elson, and Megan Canning at the Design Trust for Public Space; Fredric Nachbaur, Loomis Mayer, Helen Tartar, and Eric Newman at Fordham University Press; Clare Weiss and Meg Duguid at the New York Parks Department; and last but not least, Claudia Bonn, Jennifer McGregor, and Leigh Ross at Wave Hill.

This magnificent and important exhibition would not have been possible without the generous support of The J. Ira and Nicki Harris Family Foundation; Council for Cultural Affairs, R.O.C., in collaboration with Taipei Cultural Center of TECO in New York; Graham Foundation for Advanced Studies in the Fine Arts; National Endowment for the Humanities; The Paul and Klara Porzelt Foundation; the U.S. Institute of Museum and Library Services; New York State Council on the Arts, a State Agency; Kodak; and Jane Wesman and Don Savelson. We are also grateful to The Greenwall Foundation's Oscar M. Ruebhausen Commission for its support of Katie Holten's *Tree Museum*, and the Starry Night Fund of Tides Foundation and Dolan & Traynor / DuPont Corian® for their support of the Lobby Project by Vito Acconci.

We would also like to acknowledge the following individuals for their role in granting the Museum rights and reproductions: Ariane Pereira de Figueiredo, Projeto Hélio Oiticica; Faye Haun Licensing Manager, Museum of the City of New York; and Jill Slaight, Department of Rights and Reproductions, New-York Historical Society. I deeply appreciate the efforts of Melanie Bower, Manager of Collections Access, Faye Haun, Licensing Manager and Abby Lepold, Associate Registrar, Museum of the City of New York; Kitty Cleary, Circulating Film & Video Library, Katie Trainor at the Film Department, Stefanii Ruta Atkins, Registrar, Collections, and Ellen Conti, Assistant Registrar, Collections Management and Exhibition Registration, The Museum of Modern Art, New York; Emily Foss, The Metropolitan Museum of Art, New York; Heidi Nakashima, Conservator for Exhibitions and

Loans, and Scott Wixon, Collections Manager, New-York Historical Society; Mike Homer and Nancy Rattenbury, Associate Registrar, PaceWildenstein; and Julie Saul, Julie Saul Gallery, New York for her support and assistance regarding Jeff Chien-Hsing Liao's work.

The following curators were instrumental in the production of this project: Malcolm Daniel, Curator in Charge, Department of Photographs, The Metropolitan Museum of Art, New York; Kathleen A. McAuley, Curator, The Bronx County Historical Society; Ann Temkin, Chief Curator, Department of Painting & Sculpture, Susan Kismaric, Curator, Department of Photography, Anne Morra, Assistant Curator, Department of Film, The Museum of Modern Art, New York; Roberta J.M. Olson, Curator of Drawings, and Alexandra Mazzitelli, Curatorial Assistant New-York Historical Society.

We thank the many contributors to this publication: Daniel Libeskind, Ray Bromley, Francis Morrone, Deborah Marton, Jennifer McGregor, and Clare Weiss. We thank Thierry Debaille for coordinating Mr. Libeskind's participation in this project. We also thank Edward A. Toran for additional architecture photography; Bill Orcutt, for his installation photography; interns Eve G. Ahearn, Ezequiel Jimenez, and Erica Palmiter; Guy Willey for his installation design; Hatuey Ramos Fermin for his film editing; Jason Kocher for media and technical assistance, Sergio Bregante and Joaquin Gallego for their design of this publication and all printed material related to the exhibition; and Vajra Kilgour and Eric Newman for catalog copyediting.

Finally, we are eternally grateful to the dedicated and hardworking staff of the Bronx Museum, particularly Antonio Sergio Bessa, Director of Programs; Lynn Pono, Programs Manager; Erin Riley-Lopez, Associate Curator; Alex Schneider, Registrar; Kai Vierstra, Preparator; Yvonne Garcia, Director of Development; Alan Highet, Director of Finance; Camille Wanliss, Director of Marketing; Jose Campos, Media Assistant; Carmen Hernandez, Coordinator of School Programs, and her wonderful team of instructors: Calder Zwicky, Hatuey Ramos-Fermín, Ivan Velez, Kathleena "Lady K. Fever" Howie-Garcia, and Edwin Gonzalez; and Francisco Rosario, Director of Security. Last, I would like to thank the Bronx Museum's Trustees past and present for recognizing and supporting this significant occasion in the history of the Bronx.

FOREWORD
DANIEL LIBESKIND

The Bronx formed a substantial part of who I am and how I see the world. When I came to America as an immigrant, my parents were factory workers. Somehow, we wound up in the Bronx, and that was the best thing that could have happened to me because I discovered so many things here, so many things about America. Of course, I was fortunate to be able to go to the Bronx High School of Science, which is one of the greatest schools in the country; but primarily it was the spirit of the people, who were mostly immigrants, that shaped me.

Where I grew up in the Bronx, there were many immigrants. Of course, where I grew up was a predominantly Jewish neighborhood, but my closest friends were Italians. There was an Irish neighborhood near Bailey Avenue. It was a very mixed area, and part of the feeling of the Bronx was that it was a cross-section of the world. Where else could you meet people speaking different foreign languages within the same block, or families that had experiences from other parts of the world that you never dreamed of? Initially we were living in all sorts of temporary quarters, as immigrants often do, and then we were lucky enough to get into social housing, in this case the Amalgamated Clothing Workers Housing Co-operative.

My mother was working in the garment industry with furs, and basically at that point this was a kind of slave labor. There was no air conditioning and no fans; in the summers, she worked in appalling conditions. But it was incredible luck that we got a low-cost apartment, very reasonable and beautiful: those apartments were beautiful places to live. I once asked my mother, "How did we ever get this apartment?", because the long waiting lists were legendary. The reason was that the people on the co-op board—who by that time were in their eighties or nineties and were former refugees from Russia, the Ukraine, and Poland, as radicals and radical thinkers—recognized my mother. My mother had a kind of anarchic strain in her thinking and in her history. These old anarchists had recognized that she was in some way part of the movement, and so we somehow got on a good list. And as a result, I discovered these incredible people living in the Amalgamated who were true fighters for workers' rights, for women's rights, the whole gamut.

The Grand Concourse is one of the great boulevards of the world, and it should be protected as a historical patrimony. It is a distinctive avenue that was not built for the rich like the Champs Élysées; it wasn't for the very wealthy—there were regular people here. It was a paradigmatic model of planning, because it organized the Bronx around this huge axis.

So what happened to a neighborhood that used to be "glued" to the Concourse? The demise of the Bronx was truly tragic, and it had a lot to do with the kind of thinking that Robert Moses instigated. Suddenly, there were rumors that it was not safe. These

were just rumors, but rumors persist and become, in their own way, true. People gave up apartments that were beautiful to go into the characterless towers built far away in Co-op City. I witnessed the demise of the Bronx and of the Concourse, which occurred for no reason at all and within a very short time, primarily because of the lack of the city's commitment to say, "No, this is a great area, no one should be afraid, there is no more crime here than anywhere else in New York"—which was true. But it's strange and sad how in an urban mindset, a neighborhood can change just on account of fear and uncertainty, in a way similar to the unfolding of the economic situation today, in which certain words make people think that the world is heading into an apocalypse.

I hope that with the new president and new social notions, housing and people are important not just elsewhere but here—right here in the Bronx—and that the Bronx can bloom again. When you read early accounts of New York, the Bronx is always described as the most beautiful borough. It's not Manhattan, not Brooklyn—it's the Bronx. Edgar Allan Poe wrote about this in some of the essays he published—and incidentally, when I came here as an immigrant, one of the first things I did was to visit his cottage in Poe Park, which is such a magical place. But you know, the Bronx *is* beautiful. It has a texture of unique housing, unique stories, immigrant worlds—good worlds. It's not just Yankee Stadium! But of course it needs an injection of resources to stabilize it and to bring it to its full glory.

Finally, I have to tell one more entertaining anecdote: the rather ironic story of why I never went to the Vietnam War. I was not a conscientious objector; I was not a draft dodger; I did not hide my name or anything like that. No, I was just very naïve. I received a letter from the Selective Service—this was the height of the Vietnam War and I was, of course, registered for the draft—to report for a medical evaluation in Brooklyn. I was astonished and scared. I was very patriotic and quite ready to go to Vietnam to serve my country, but I had never been to Brooklyn! I had no idea how to get there. It was another world away. So I wrote back a letter saying, "Dear Sirs, I'm from the Bronx. I've never been to Brooklyn. Can you please give me a check-up in the Bronx?" So some months elapsed—and, by the way, I had a very high number in the draft lottery. Another letter came, which said, "No, no, we insist that you go to Brooklyn." So I said "No, no, I don't want to go to Brooklyn. I don't know Brooklyn. I'll go to northern Manhattan." The exchange was hilarious, and by the time it ended, my number in the lottery had been passed by. But I always thought, I was sincerely ready to go to Vietnam, but not to Brooklyn. Oddly, Vietnam seemed closer than Brooklyn. That was the Bronx mentality! You lived in the Bronx, and the Bronx was your whole world.

This text was transcribed from Daniel Libeskind's keynote address at the symposium "Intersections: The Grand Concourse at 100" organized by The Bronx Museum of the Arts on March 7, 2009.

INTRODUCTION
ANTONIO SERGIO BESSA

That an entire city would rise from a sinuous line described along a ridge in the wilderness is a thing of wonder, and one must dwell on the subtle interplay of abstraction and concreteness that this image evokes in order to appreciate fully the concept of the Grand Boulevard and Concourse, the thoroughfare envisioned by Louis Aloys Risse during a hunting trip to the Bronx around 1870. Since its opening to the public in 1909, the Concourse has played a vital role in the urbanization of the borough, and despite the senseless alterations inflicted on the avenue throughout the past 40 years that led to the loss of its boulevard status, the main structure of the Grand Concourse remains intact as a groundbreaking example of city planning and urban design.

While the Grand Concourse has often been compared by architecture historians to the boulevards of Paris, the fact of the matter is that in their basic conceptualizations the two programs had entirely different intentions. Whereas Baron Georges-Eugène Haussmann's stated goal was to replace Paris's medieval layout with a network of avenues that allowed for better circulation and control, Risse's design departed from an unabashed utopian vision charged with spiritual overtones. That he was able to sell his plans to the common man and politician of his time is a measure of Risse's deft ability to articulate his vision.

Born Jean-Alloeus Risse in Saint-Avold, France, on March 28, 1850, Risse arrived in New York in 1867, where he found work as a civil engineer designing maps documenting the city's ongoing expansion. Accounts of Risse's upbringing and his emigration to New York are vague, making it difficult to determine whether he received any formal training as an engineer. A biographical sketch provided by his son Charles Risse after his death and published in the March 15, 1926, issue of *The Bronx Home News* informs us that around 1865 Risse "went to Paris, where he had relatives, and where he studied drawing and painting." By the time he arrived in New York two years later, the article adds, "he had already developed a profound taste for drawing and mathematics, and finding in this country an attractive field for the practical pursuit of engineering studies he decided to make the United States his home and civil engineering his chosen profession." A short memoir by his granddaughter Marion Risse Morris, published by the *Bronx County Historical Society Journal* (XVII, 1, spring 1980), casually mentions that Risse was a graduate of St. Cyr, and his great-grandson Griffith Morris was told that he was graduated in engineering from Cooper Union. An article in the *New York Herald Tribune* (June 13, 1948) praises Risse as a mapmaker and highlights the fact that his large-scale "General map of the city of New

York, consisting of the boroughs of Manhattan, Brooklyn, Bronx, Queens and Richmond" won the Grand Prize of the Paris Exposition of 1900. The article notes that several parks in Queens (Kissena Park, Alley Park, and part of Cunningham Park) and Richmond (Silver Lake Park and Clove Lake Park) occupy sites proposed by Risse in his maps.

One could argue that the meticulous process entailed in cartography provided Risse with an invaluable, in-depth understanding of the various spaces that would later constitute the Greater New York area, as well as their interconnectedness. His design for the Grand Concourse, on the other hand, denotes his understanding that great architecture brings people together by providing unique experiences.

According to his own accounts of the genesis of the Concourse in two texts included in the present volume, Risse's vision for the thoroughfare came about during a hunting trip to the Bronx when he was about twenty years old. In the first account, published in 1897, Risse's sensitivity to nature and landscape is evident. "Nature," he writes, "has provided a Grand Boulevard and Concourse for the North Side and the City of New York such as no other city in the world possesses," and his narrative goes on to develop a rationale for not leveling the ridge: "To grade this beautiful upland to a level with the street system east and west and destroy its commanding view would have been a heartless desecration." Throughout the text Risse displays the reverence for nature and sensibility to site that one finds in architects like Frank Lloyd Wright, whose design for Fallingwater, also known as the Edgar J. Kaufmann Sr. Residence, in southwestern Pennsylvania equally proved that architecture need not subjugate nature.

Risse's investment in protecting the Concourse from mundane distractions is of such order that technical solutions like the transverse roads, for instance, seemed to have been concocted solely to maintain the goal of an "unimpeded" throughway atop the ridge. This is urban thinking of the highest order—one that does not go against the given elements of nature but rather works with and through them. Not unlike Haussmann, however, Risse is also looking toward the future: "What is wanted," Risse wrote in the second account, published in 1902, "is a street system adapted to the city that is to come, and not to the infant, so to speak, which exists today. This means the making of a street system which will not require to be unmade before a period of twenty years has passed away." He also wishes his road to be "secure forever against the intrusion of trade," a well-intended concern that one hundred years later has become a major element of contention in the community as cultural trends and commercial needs evolved.

Risse's original intent was to provide a space to bring neighbors together in leisure, not in shopping. His careful regard for neighborhood and city dwelling is grounded in the humanistic tradition that considers cities not only as *urbis* but also *civitas*—to paraphrase Lúcio Costa, the planner of Brasilia, a city whose design also shares with the Grand Concourse the model of the "viaduct city."

The changes undergone by the Grand Concourse in the past century may offer lessons for a better understanding of the role of design in building communities—most specifically, how flexible a design ought to be in order to allow the members of a community to make it their own. Concocted on the brink of modernism, Risse's design came to fruition a few decades before more extreme urban schemes were proposed. Plans like those Le Corbusier envisioned for Rio de Janeiro and Algiers in 1930, for example, despite their equally sinuous outlines and playful rapports to landscape, look overwhelming and artificial compared with Risse's careful integration of his structure with nature. Ultimately, Corbusier's bravado gave way to more mechanistic designs like Ville Radieuse and its programmatic segregation of human activity into predetermined zones.

In designing the Grand Concourse, Risse placed nature and human interaction at the center of his concerns, and despite the loss of trees and promenade lanes, many essential traits envisioned by Risse endure, hinting at the design's ability to evolve. Along the avenue the well-proportioned buildings still look "right," validating the design's regard for human scale while also offering at certain points spectacular views of the borough to both sides of the ridge. Whether one is walking or traveling by conveyance, moving on an elevated plane through successive vistas along the Grand Concourse is a unique experience in the entire city of New York.

While the survival of many of these features is clearly due to zoning policies, it is undeniable that throughout the past century residents along the Grand Concourse have effected change, most controversially by introducing commerce in areas that were once exclusively residential. The avenue also stretches farther down to 138th Street; and amidst residential buildings, churches, and landmarks like the Post Office and the Bronx County Courthouse, it now includes the Bronx Museum of the Arts, Hostos Community College, the Bronx County Housing Court, and Bronx-Lebanon Hospital, among others.

Intersections: The Grand Concourse at 100 pays homage to Risse's visionary spirit and looks back through the past hundred years to assess the relevance of his Grand Concourse. The conceptualization of the Grand Concourse as well as the process that led

to its realization are here presented in Risse's own words in two essays reprinted verbatim from original publications. A selection of original maps related to the project is also featured, in addition to archival images documenting the construction. To contextualize the Grand Concourse in a broader historical framework and consider the changes it has seen, we engaged two leading scholars in the area of urban studies and architecture, Ray Bromley and Francis Morrone. As a conclusion to the volume, Deborah Marton reflects on some of the main ideas put forth by young architects and urban planners in response to an international ideas competition, organized by the Bronx Museum and the Design Trust for Public Space, to envision the future of the Grand Concourse.

The volume also features documentation of six art projects especially commissioned by the Bronx Museum of the Arts, including a series of large-scale photographs by Jeff Chien-Hsing Liao documenting the present condition of the Grand Concourse and the surrounding area; a public art project by Katie Holten produced in collaboration with Wave Hill and the Parks Department, in which the artist conceptualizes the Grand Concourse as a "museum of trees"; a timeline project by the Bronx artist Skowmon Hastanan that provided most of the material for the Chronology section of this volume; an installation by Kabir Carter in which live sounds from the Grand Concourse are captured, processed, and distributed into the Bronx Museum's galleries; a three-channel video work by Pablo Helguera about three buildings on the Grand Concourse—Edgar Allan Poe's cottage, the Andrew Freedman Home, and the Lowe's Paradise theater; and an architectural intervention in the Bronx Museum's lobby by Acconci Studio in which strips of Corian® work as a hard fabric, slit, folded, stretched, and curved into complex geometries.

In the coming years, the Bronx in general, and the Grand Concourse in particular, will face an entirely new set of challenges, including environmental issues, gentrification, the expansion of cultural resources, and the preservation of the area's historic character. The historical documentation and original artwork gathered in *Intersections: The Grand Concourse at 100* look back at the past with an invitation to envision the future.

ESSAYS

LOUIS A. RISSE

RAY BROMLEY

FRANCIS MORRONE

HISTORY IN BRIEF OF THE CONCEPTION AND ESTABLISHMENT OF THE GRAND BOULEVARD & CONCOURSE IN THE 23rd AND 24th WARDS

Louis Aloys Risse

After the election of the late commissioner Louis J. Heintz, and the organization of the new department of Street Improvements, created under Chapter 545 of the Laws of 1890, it became the duty of the Chief Engineer of that Department to revise the street system of the 23rd and 24th Wards as established by the Department of Public Parks and create and lay-out a permanent system which would meet with the approbation of the general public and the approval of the authorities; a street system which would not be open to the liability of any future changes in its essential features, but a street system which was to be completed within a specified time and would be final and conclusive.

As is well known, the original lay-out of the Parks Department was defective in many ways, and radical changes in some sections were necessary for the benefit and future development of the district. One of the most noticeable features on the old plans was the omission of a suitable road connection between the lower end of the 23rd Ward and the upper parks in the 24th Ward. This connection was also omitted by the Commission appointed by the Legislature in 1883 "to select and locate lands for public parks in the 23rd and 24th Wards and the vicinity thereof." The plans of that Commission provided suitable parkways connecting the new parks but failed to provide a connection between them and the Harlem River, and the central portion of Manhattan Island.

To be sure, Jerome Avenue, Webster Avenue, Third Avenue, Boston Avenue and the Southern Boulevard all lead to the New Parks, but they are or will be great thorough-

fares and main arteries of business and not at all suitable for a Pleasure drive or Park connections. This omission made it incumbent on the New Department to provide a broad thoroughfare or boulevard on the New General Plan of the final street system, and located in such a place that its establishment would be secure forever against the intrusion of trade.

The knowledge of the topographical features of the high ridge extending from Mott Avenue to the Mosholu Parkway, dividing the water sheds of the Cromwell's Creek and Mill Brook valleys suggested the advisability of taking elevations and studying the topographical plans and using the information shown on the general plans on file in the department. The result of this investigation showed the practicability of using this ridge. The feasibility of extending Mott Avenue northerly as a park approach was determined upon as the proper location for a Grand Boulevard and Concourse. This of course necessitated the remodeling of the street system west to Jerome Avenue and east to Webster Avenue, but supplied the missing link of the Park system referred to above. The proposition was made to call it a "Public Drive," "Grand Boulevard," but as there existed already roads in the city known as such, it was necessary that a name should be selected which would distinctly show that the road was located north of the Harlem River and the name "Concourse" was suggested and adopted. This was in 1891.

Early in 1892 the agitation for a speedway in Central Park was in progress but the opposition it created and the probable repeal of the bill by the Legislature suggested the advisability and advantages of locating this speedway and making it an added feature of the proposed "Concourse." Opinions differed; some thought that Jerome Avenue was better adapted for that purpose, it being a continuation of Seventh Avenue and by enlarging it to 200 feet it could accommodate the fast drivers and the ordinary traffic. This plan, however, was not adopted for it was clearly shown and demonstrated that at the best it would only be a makeshift and could only be used as a speedway for a limited number of years when it would have to be located somewhere else.

The advantage of locating this speedway on a high elevation where it would be possible to have the principal cross-town roads pass underneath so as not to interrupt speeding was favorably received, and it was decided to transfer the location of the speedway from Jerome Avenue and make it one of the features of the new proposed "Concourse."

The plans for the Grand Boulevard and Concourse were prepared and provide for 23 transverse roads (which have since been reduced to nine). These plans were submit-

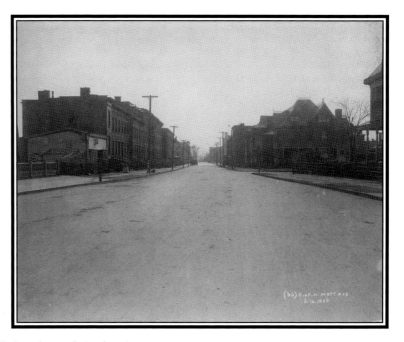

MOTT AVENUE, MARCH 16, 1909
Photographer unknown
The Bronx County Historical Society Collections

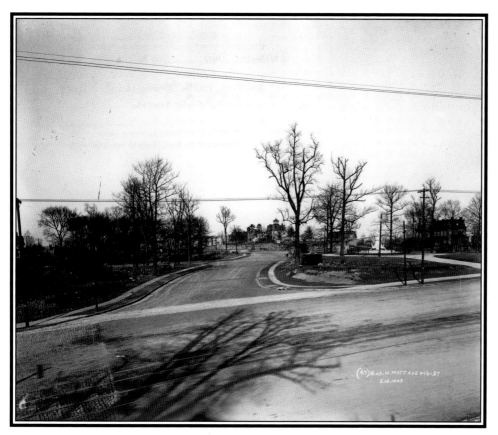

MOTT AVENUE, 1909
Photographer unknown
The Bronx County Historical Society Collections

ted to the people of the 23rd and 24th Wards at different public hearings, notably the one held in the Department building in January 1893, when the most prominent residents of the two wards appeared and in the most enthusiastic speeches gave their endorsements and approval of the scheme.

The plans were also submitted to the public authorities who approved of them as great public improvement and to the public press which commented on them very generally and very favorably.

The maps showing the new street system with the Grand Boulevard and Concourse laid out as a feature were submitted to the Board of Street Opening and Improvement who, after several public hearings to which the people in general were invited, they were finally approved of, adopted and were ordered filed according to law, which was done and which made them final and conclusive.

In 1895 a bill was introduced in and passed by the Legislature providing for the taking and paying for the right of way for the Grand Boulevard and Concourse and on which a hearing was given by the Mayor on the 7th of March that year. At this hearing a very large and influential number of residents and property owners were present who, without a single exception, gave their most enthusiastic approval of the bill. The bill was signed by the Mayor the same day and became a law under the Governor's signature on the 20th of March, as Chapter 130 of the laws of 1895.

The plans and profiles as required by this law were filed as follows:

With the Commissioner of Street Improvements, June 26th, 1895
With the Registrar, June 27th, 1895
With the County Clerk, June 28th, 1895

The rule map showing the land to be acquired was forwarded to the Counsel to the Corporation on July 2nd, 1895, and on August 15th 1895, three Commissioners

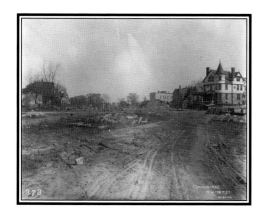
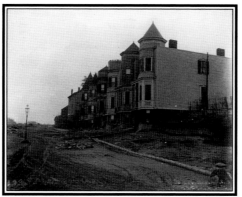

were appointed by the Supreme Court for the purpose of making a just and acquitable (*sic*) estimate and assessment.

The Draft Damage maps were requested by the Counsel to the Corporation on August 27th, 1895, and were forwarded as follows:

The first section, from E. 161st Street to E. 173rd Street on Sept. 30th, 1895
The second section, from E. 173rd Street to Burnside Ave. on March 7th, 1896
The third section, from Burnside Ave. to E. 184th Street, on June 30th, 1896

The Final Damage maps were forwarded as follows:

The first section, from E. 161st Street to E. 173rd Street, on April 13th, 1896
The second section, from E. 173rd Street to Burnside Ave. on December 17th 1896
The first section was presented for confirmation to the Supreme Court on June 5th, 1896, and was confirmed on February 16th, 1897
The second section is to be presented to the Supreme Court for confirmation on March 30th, 1897

On August 24th, 1897, title will vest in the city to all the lands within the lines of the Grand Boulevard and Concourse from East 161st Street to the Mosholu Parkway and to all the transverse roads. viz; East 165th St., East 167th St., East 170th St., Belmont St., Tremont Ave., Burnside Ave., Kingsbridge Road, Southern Boulevard and East 204th St. (Potter Place) by virtue of section 5 of Chapter 130 of the Laws of 1895 which says: "If, however, at the expiration of two years from the date of the filing of the oath of said Commissioner of estimate and assessment, no report of said Commissioners of estimate and assessment shall have been made and confirmed by the court, then immediately

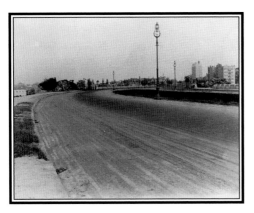

upon the expiration of said two years the title of the real estate embraced within said Boulevard and Concourse and transverse roads as laid out and established by the said Commissioner of Street Improvements, and in any property, right, term, easement, or privilege in the same, shall vest in and be the property of the Mayor, Aldermen and Commonality of the city of New York, in trust nevertheless as hereinbefore mentioned."

THE GRAND BOULEVARD AND CONCOURSE

Nature has provided a Grand Boulevard and Concourse for the North Side and the City of New York such as no other city in the world possesses. Northward from the Cedar Parks, west of the Harlem Railroad and between Jerome and Webster Avenues stretches a magnificent ridge extending all the way to Mosholu Parkway near Van Cortland Park, a distance of four and one quarter miles. Its varied topography, charming views, natural condition and peculiar adaptability for a Grand Boulevard and its location, geographically considered, is in the centre of the upper half of New York City, where means of access for the entire Metropolis can be furnished. The location is selected on top of an almost continuous crest and the solution of the most difficult question, how to cross the Concourse without interfering with the unimpeded use of it is by constructing transverse roads under the same. The summit of this ridge, which it would be a sacrilege against Nature to disturb, is the line upon which the Concourse is located. To grade this beautiful upland to a level with the street system east and west and destroy its commanding view would have been a heartless desecration. In a word, Nature seems to have specially designed this ridge for a grand approach to the New Parks and, in the opinion of many, its appropriation for any other purpose would have been a serious mistake, costing more in the end than the amount expended in securing possession. The Grand Boulevard and Concourse running from Mott Avenue at East 161st Street to Mosholu Parkway communicates, through this parkway, with Van Cortlandt and Bronx Parks and by way of Bronx and Pelham Parkways with Pelham Park. At this southern extremity it will connect, by means of a viaduct approach, with the Central Bridge over the Harlem River and will be readily accessible from all parts of the North Side and Manhattan Island so that the magnificent park areas which the City so wisely acquired will be made readily available to the vast population of our rapidly growing city. At the present time, to the vast majority of New Yorkers, they are accessible only with the incidents of delay, difficulty and discomfort. Largely increased railway facilities are needed, as well as a grand driveway by which those who wish to visit the Parks in carriages may do so easily and pleasantly. The new Parks are therefore, as far as vehicles are concerned, cut off from the other parts of the city, and the enormous benefit to be derived from the purchase of this land is entirely neutralized because there are no communications.

The Grand Boulevard and Concourse will be 182 feet in width and will provide walks, sidewalks, promenades, bicycle paths, driveways, etc. The transverse roads will occupy the central strip of the principal cross streets, on each side of which an exterior strip upon the proper grade of the street will afford access to the abutting property and residences thereon. The Concourse can thus be reached at every intersecting street by all desiring to drive upon it. Its great width and ample provision for every kind of demand that can be made upon its space from walking to speeding makes it perfectly adapted to all the purposes for which a Concourse can be utilized. Two bicycle paths are provided between the drive and the promenade on either side of the Concourse, thus assuring the riders going north and south a direct pathway without the danger of meeting others coming in an opposite direction. When the Concourse is completed the Cyclist can ride through Central Park up Seventh Avenue to the Central Bridge and viaduct approach to the Concourse to Van Cortlandt Park, through Mosholu Parkway to Bronx Park and through Bronx and Pelham Parkway to Pelham Bay Park, a distance of over 14 miles.

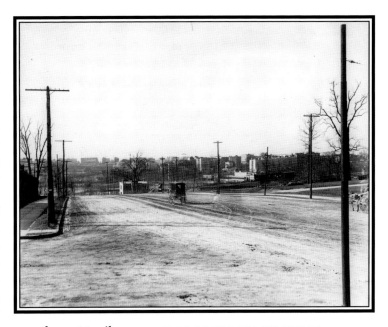

GRAND BOULEVARD AND CONCOURSE
Photographer unknown
The Bronx County Historical Society Collections

It is to be hoped that the execution of this project will not be further delayed. Miles of New Streets are being opened, lines of dwellings are extending to all points within the 23rd and 24th Wards, and in a few years a new city with nearly a million inhabitants will have arisen on the North Side, and it is not necessary however to wait for this increase of population to execute this grand project which will take years to finish. Viewed from a financial aspect alone, it will prove a most profitable investment for the city, a magnificent real estate speculation, which will net the public treasury many a million dollars over and above even the most prodigal expenditure. The Grand Boulevard and Concourse will enrich the city, enrich the property owners, enrich the North Side, and impoverish and injure none. From the greatly enhanced value of the land, which as experience in New York has shown the City will derive, from year to year, an increased income that will materially lighten the expense of the other necessary public works.

The importance of the subject demands for it the earnest consideration of our authorities affecting as it does in a peculiar degree, the interest of the Metropolis.

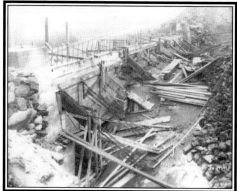

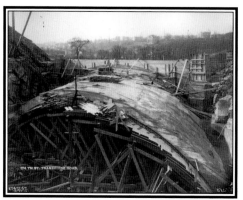

MOULDED CONCRETE FOR 174th BRIDGE
Photographer unknown
The Bronx County Historical Society Collections

174th ARCH
Photographer unknown
The Bronx County Historical Society Collections

TRANSVERSE ROAD, 1913
Photographer unknown
The Bronx County Historical Society Collections

ARCH SKELETON, 1913
Photographer unknown
The Bronx County Historical Society Collections

[opposite page]
174th STREET AND TRANSVERSE ROAD, 1913
Photographer unknown
The Bronx County Historical Society Collections

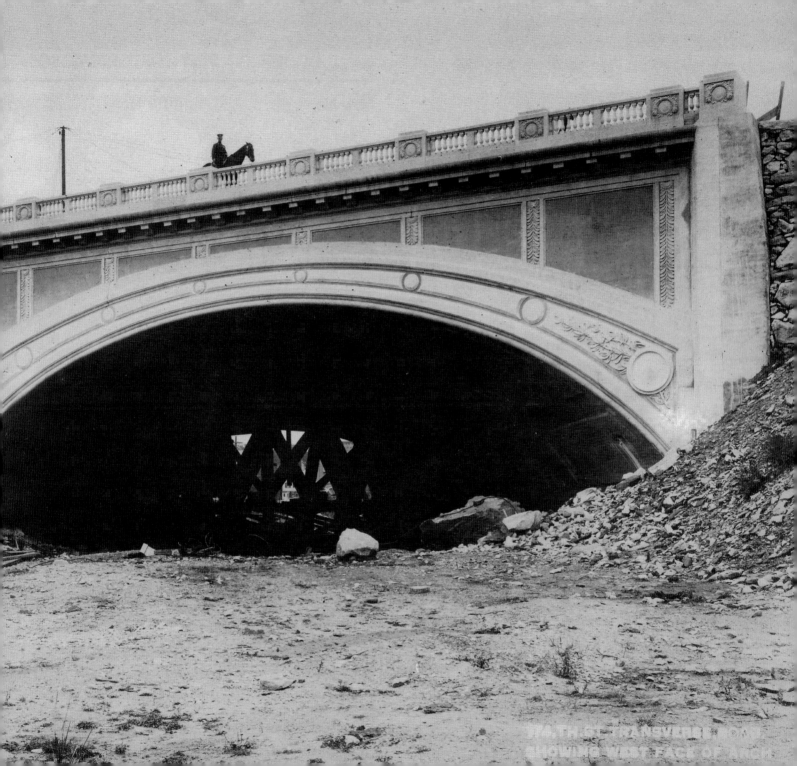

THE TRUE HISTORY OF THE CONCEPTION AND PLANNING OF THE GRAND BOULEVARD & CONCOURSE IN THE BRONX

Louis Aloys Risse

In order to bring out the facts preliminary to the true history of the original conception and planning of the Grand Boulevard and Concourse I will go back a number of years to a period which if not directly connected with the story, has at least some bearing upon it, inasmuch as certain events and observations of that time were subsequently recalled to good advantage.

In 1870—71 and 72 while engaged in making the map of the "Town of Morrisania" for the Commissioners appointed under an Act of the Legislature passed in 1868, it was my custom on Saturday afternoons during the hunting season to meet three of my young men friends at my office, which at that time was located at 138th Street and 3rd Avenue. From there we would start out on a hunting trip which was scheduled to last until Sunday night.

We used to take the old "Huckleberry" horse car and ride out to what is now Tremont Avenue. Alighting there we would shoulder our hunting traps and hike up the Mount Hope Hill to the old one-story stone Inn, which at that time was conducted by an aged Frenchman as a lodging house for hunters. This quaint building, formerly a farm house, was located in that section of Mount Eden near to what is now known as 173rd Street. It was built upon the high rocks on a wooded ridge overlooking the Jerome Avenue Valley to the West and Mill Brook Valley to the East.

At four o'clock in the morning my companions and I would start out upon our hunt for quail, grouse, rabbit or whatever other game was to be found on the tracts over

which we ranged. The expedition would take us as far North as Woodlawn and usually we made our way southward to the Morris Estate and Fleetwood Park. This entire stretch of territory at the time was a vast wilderness, with rocky cliffs descending abruptly in many places and steep inclines of rugged land sloping down to the valleys on either side.

By tramping over this territory repeatedly on my hunting trips I naturally acquired a familiar knowledge of its topography and this knowledge was subsequently augmented by actual surveys which I made of that same land while in the employ of the Parks Department which began in 1875. Later while Superintendent of the 23rd and 24th Wards, this very territory came under my direct supervision. As Superintendent it was my duty to maintain the existing roads under my jurisdiction in good condition for travel and wherever necessary to establish new streets for communication not only between points of current importance, but also between those which foresight suggested as likely to become the prominent places of the future. About this time the fact came to my notice that there

NORTH OF 166th STREET, 1904
Photographer unknown
The Bronx County Historical Society Collections

was not an existing cross road over the ridge above mentioned at any point between Arcularius Place (now 169th Street) and Waverly Street (now 177th Street). At some point between these two streets I was to open a new street over the ridge by authorization of the Department. The street eventually opened was Walnut Street. In order to avoid excessive grades on either side the ridge, it was necessary in putting this street through to cut down for a depth of forty feet through solid rock. I saw from this that the properties on both sides of the cut, which were left high and dry, were thus rendered unsuitable for building purposes and consequently unsalable. For a time it seemed likely that opening other streets through the ridge would be a prohibitive matter and that the entire section involved must necessarily remain unimproved perhaps for many years.

The Parks Department, which then had jurisdiction over the "Annexed District," made little or no progress in developing that territory. The opinion seemed to obtain at the time that the Bronx was but a suburban section of the city and the street lay-out prepared for it therefore, was distinctly a park system plan rather than a city street lay-out. Obviously, such a plan was highly detrimental to the territory it would lay out.

In 1884 a Law was enacted creating a Commission to acquire the necessary lands for Public Park purposes. The work of that Commission was completed after a number of years and about 4000 acres of land had been acquired for parks. Most of this park acreage was located in the northern section of the Bronx. That no provision was made

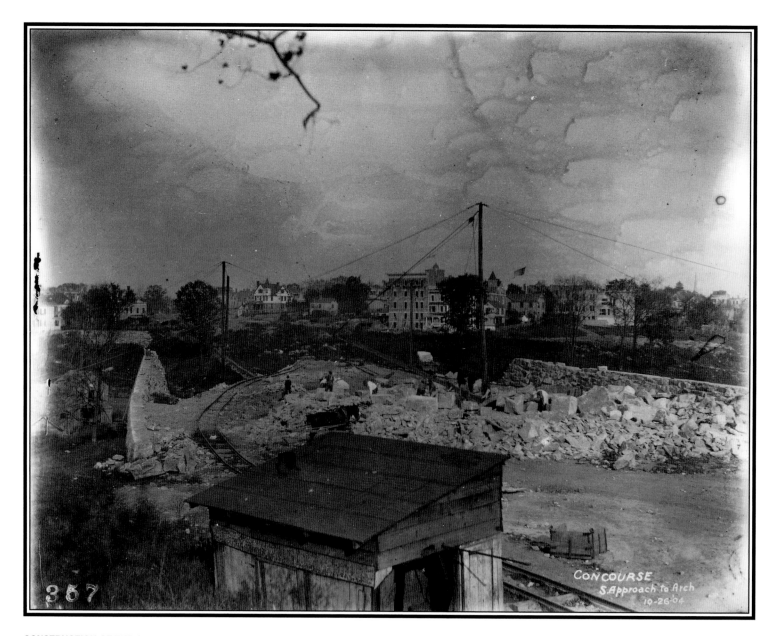

CONCOURSE
S.Approach to Arch
10-26-04

357

CONSTRUCTION OF THE GRAND BOULEVARD & CONCOURSE
Photographer unknown
The Bronx County Historical Society Collections

at the time for securing the needed lands by which a connecting link could have been established between the Northern park systems and the City Parks proper was a gross omission that long stood in need of rectification.

When in 1886 I resigned from the Parks Department to engage in my own private practice as City Surveyor, the Department had as yet done little toward improving the district under its jurisdiction. On this account the people voiced their resentment so effectively that their protestation brought about an investigation by the Legislature.

Some time after my resignation from the Department I was invited by the late Adolph G. Hupfel to meet Mr. John C. De La Vergne, head of the De La Vergne Refrigerating Company, who was then examining local sites with a view to erecting a large refrigerating plant. We inspected a number of possible sites along the East River, finally selecting the present site of the De La Vergne plant at Port Morris. From that time on my acquaintance with Mr. De La Vergne developed into a warm and lasting friendship.

In the meantime the agitation against the Park Department became so pronounced that a committee of citizens was formed for the purpose of drawing up a bill to create the Department of Street Improvements of the 23rd and 24th Wards. After a number of set-backs this bill was finally approved and became a law. Subsequently, Louis J. Heintz was elected the first Commissioner of Street Improvements of the 23rd and 24th Wards. Mr. Heintz took office on the first day of January, 1891.

The new Commissioner honored me by appointing me his Chief Engineer. In accepting the appointment, I called to Mr. Heintz's attention the fact that the law directed the new Department to create an adequate street system for the 23rd and 24th Wards and that the work was to be completed not later than 1895. This was indeed a short time in which to accomplish an undertaking of such magnitude. I further expressed to Mr. Heintz my hopes that he would stand by me to combat all influences and interferences from outside sources that might attempt to hamper my judgment in the matter of the most suitable street lay-out for the territory under consideration. The Commissioner assured me that so far as it lay in his power he would permit no obstacles to come between me and my work a promise which he well fulfilled.

At about the time that Mr. Heintz took office the agitation for a Speedway along the west side of Central Park was at its height. The Rider and Driver Club was behind the scheme Hugh S. Grant was then Mayor of New York City. Adverse criticism by the public press and determined opposition of the people against the project doomed it to complete failure.

Mr. John C. De La Vergne, then President of the Rider and Driver Club, called on Commissioner Heintz for the express purpose of laying before him the proposition of converting Jerome Avenue into a Speedway. Mr. Heintz referred him to me. I informed Mr. De La Vergne that I would be willing to prepare a plan showing Jerome Avenue

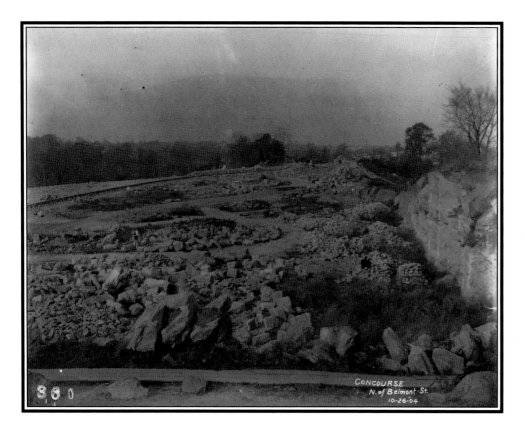

In photo: CONCOURSE
N. of Belmont St.
10-26-04

NORTH OF BELMONT STREET, 1904
Photographer unknown
The Bronx County Historical Society Collections

[opposite page]
SOUTH OF BELMONT STREET, 1904
Photographer unknown
The Bronx County Historical Society Collections

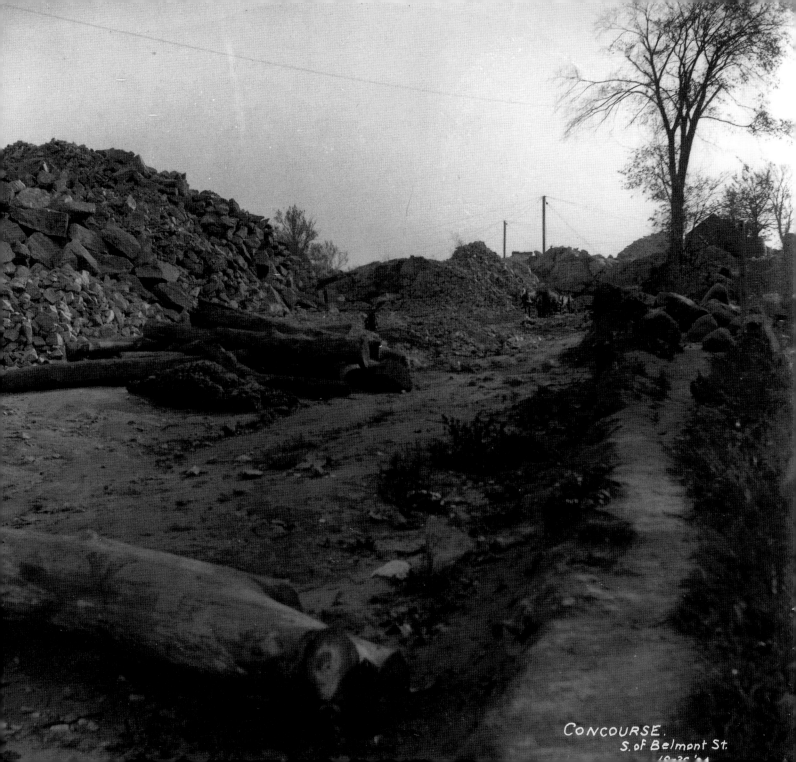

CONCOURSE.
S. of Belmont St.

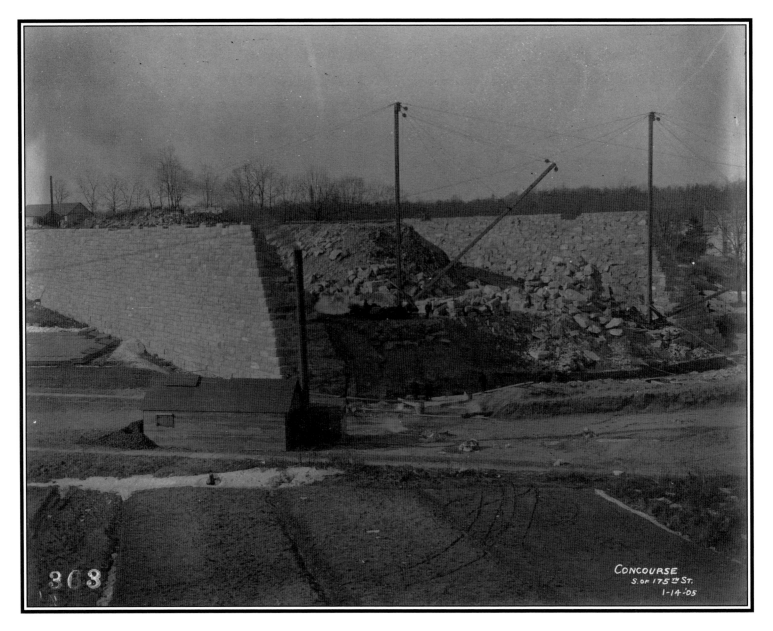

SOUTH OF 175th STREET, 1905
Photographer unknown
The Bronx County Historical Society Collections

widened to 200 feet. A width of 100 feet being provided for use as a Speedway for fast horses and bicycles and the remaining width of 100 feet to be for the accommodation of ordinary business traffic. But I further explained that in my opinion a Speedway on Jerome Avenue would be only a make-shift as Jerome Avenue in the future would most certainly become a main artery of commerce and traffic. "I believe you are right," said Mr. De La Vergne. "Think this matter over well and see if you cannot select a good and suitable location for a new Speedway."

That very night I pondered over the subject long and earnestly. Coupled with this matter of a Speedway I was giving serious consideration to the necessity of supplying that missing link between the upper and lower park systems which the Commission had failed to provide in 1884. It was then that I recalled that rocky ridge east of Jerome Avenue with which I had been so impressed during my hunting days. And at once the idea occurred to me that this ridge could be well utilized as a location upon which to build a broad and grand avenue that would serve the dual purpose of a connecting link between the Park systems and a Speedway or Grand Concourse. Further deliberation convinced me that in order to overcome the excessive grades which would result in streets built transversely to this broad avenue, it would be necessary to have all such streets pass under the Concourse.

Having revolved the entire project in my mind as I viewed it mentally from every angle, I reached the positive conclusion that it could be done and that it should by all means be accomplished—thus the original conception of the Grand Boulevard and Concourse in the Bronx.

A day or two later I took Commissioner Heintz out with me to view this ridge and as we gazed at it together I explained to him in detail my idea for building a broad avenue on it with transverse streets passing underneath. To me that day is memorable. Commissioner Heintz and I were standing at a point in front of Captain Sibbern's Road House on Jerome Avenue, from which we had an excellent view of the ridge and the hills sloping down front of it. As I unfolded my plan to the Commissioner, explaining how the broad avenue I purposed building on the ridge would serve both as a speedway and a connecting link between the Park systems, and how I intended the transverse streets to pass under the Concourse, he stared at me as though he thought I ought to be removed at once to an institution for the feeble minded.

At length, when the Commissioner had somewhat recovered from the shock to which my seemingly wild idea had subjected him, he turned to me with a quiet smile and taking my arm in his pointed to the rocky ridge of land which I had just indicated to him as my choice for a great roadway site. "Are you in earnest?" he questioned. "Do you really intend to lay out a Grand Boulevard along the tops of those slopes with the necessary cross streets so designed as to pass under it?"

"Exactly so, Commissioner," I replied. "The project is well within the range of engineering possibilities and the great enhancement in real estate values which the construction of this Concourse must necessarily produce will repay the City many times over the original cost of the undertaking." Toward the end of our discussion the Commissioner began to realize that my idea was not altogether so unreasonable as he had at first thought it to be. In fact, such was his confidence in it finally, that he turned to me saying: "Risse, I appointed you my Chief Engineer because I had faith in your judgment and ability. Let me again assure you that I intend to rely on that judgment and ability in all matters coming under your jurisdiction—go right ahead with your Concourse idea and trust me to keep my former promise that you shall not be intermeddled with in the pursuit of your original ideas." Then he added facetiously, breaking into that familiar laugh that characterized his cheerful disposition, "but watch out, Chief; have a care that you don't get me in 'Dutch' with this project of yours for a Grand Boulevard and Concourse."

Encouraged by the assurances of his support which I had received from Commissioner Heintz, I personally made a complete study of all the topographical details of the entire region that was to be affected by the contemplated improvement. I pursued these studies quietly and alone as I was not yet prepared to take the matter up with my assistants.

As already intimated, the impression I had received in the old hunting days of the rocky ridge with its great sloping sides, was ever present in my mind. As my idea of a Grand Boulevard and Concourse built upon this ridge assumed more and more definite form in my mental vision, I could easily fancy that inestimable benefits would be derived in the future from so vast an improvement.

When next I met Mr. De La Vergne he was eager to know what, if anything, I had done in the way of selecting a site for a new drive or Speedway. I then explained to him my conception of a plan for combining the missing Parkway link with the desired Speedway by so constructing streets that intersected with it as to have them pass under it. At once Mr. De La Vergne became warmly interested in the position. In an interview with Commissioner Heintz he declared himself heartily in accord with my project and straightaway pledged himself to give it ardent support.

Some time later, at a private meeting held at the Schnorer Club, I was directed to embody my ideas in a set of plans and sketches notwithstanding the fact that no City funds were available for defraying the costs of printing the same for distribution. It was then agreed that the Rider and Driver Club would undertake to raise a fund of $5000 for the purpose. On the spot Mr. John C. De La Vergne subscribed $1000. Before long the entire fund was raised and accordingly the work of preparing the plans was carried to completion. These original plans called for twenty-three transverse roads.

Commissioner Heintz submitted the plans for the Grand Boulevard and Concourse to the people of the 23rd and 24th Wards at different public meetings, notably the one held

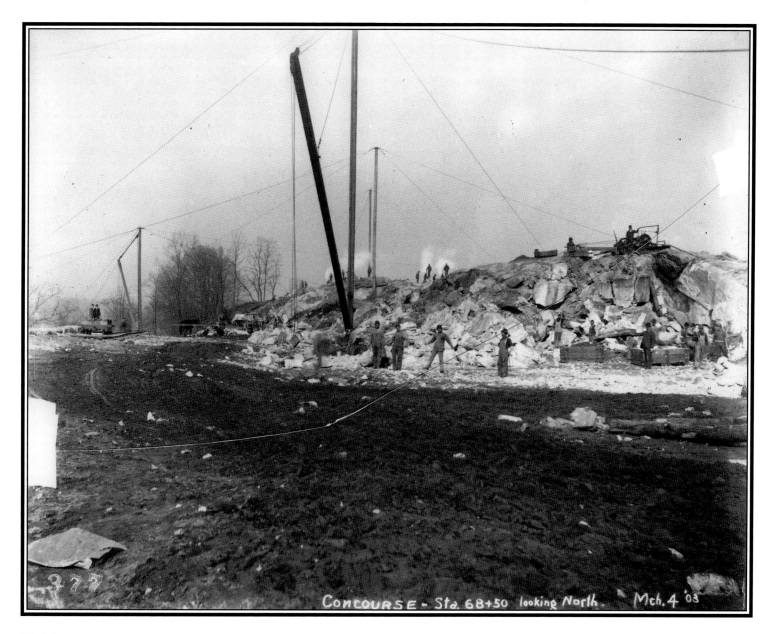

Concourse - Sta. 68+50 looking North. Mch. 4 '03

CONSTRUCTION OF THE GRAND BOULEVARD & CONCOURSE
Photographer unknown
The Bronx County Historical Society Collections

on January 31st, 1893, when the most prominent residents of the two wards appeared, and in the most enthusiastic speeches, gave their endorsements and approval of the scheme.

These plans were also submitted to the public authorities who approved of them as a great public improvement and to the public press which commented on them very generally and very favorably.

On April 1st, 1893, after the death of Commissioner Heintz the undersigned officially transmitted the completed maps and plans to the Hon. John H. J. Ronner, Deputy and Acting Commissioner of Street Improvements, with the following communication, viz:

April 1 1893.

Hon. John H. J. Ronner,
Deputy and Acting Commissioner of Street Improvements
of the 23rd and 24th Wards

Dear Sir:

Public opinion on the North Side is emphatically and enthusiastically unanimous upon the question of the Grand Boulevard and Concourse, as proposed by the late Commissioner, Louis J. Heintz.

This department was specifically created by the Legislature for the purpose of bringing about the creation of a permanent street system for the 23rd and 24th Wards; permanent in the sense that it would not be open to the liability of any future changes in its essential features. The North Side does not solicit any such experience above the Harlem as the Elm Street improvement and the College Place widening, which will cost the City a large sum of money.

What is wanted is a street system adapted to the city that is to come, and not to the infant, so to speak, which exists today.

This means the making of a street system, which will not require to be unmade before a period of twenty years has passed away; at the present rate of increase of our city population the census of 1910 might show a million inhabitants for the North Side. All this means a tremendous tide of travel to and from what are now the "New Parks," and a boulevard will be needed to accommodate the constantly swelling hosts of pleasure-seekers who will visit the parks in numbers, which will make the present influx to Central Park seem insignificant in comparison.

At present there is absolutely no avenue connecting Manhattan Island with the new parks, acquired by the city at a cost of over $9,000,000. To be sure Jerome Avenue, Webster Avenue, Third and Boston Avenues, and the Southern Boulevard all lead to the new parks, but they are great thoroughfares and main arteries of business, and each of

them has already been appropriated as the route of elevated or trolley roads or both.

This double congestion caused by the combination of railroads and business wholly unfits these avenues for boulevard purposes.

A boulevard is a promenade, a drive an avenue of pleasure—everything in fact except a commercial thoroughfare. Carriages and trolley cars cannot run on the same avenue, and the endless procession of the family parties, enjoying the air, beaux and belles, the long array of children in the charge of solicitous nurses and anxious mammas, and the other boulevard travelers, do not take kindly to trucks and freight traffic.

Pleasure and business should be kept apart, each obstructs the other. Nature has provided a grand boulevard for the North Side in the City of New York such as no other city in the world possesses.

Northward from Cedar Park, west of the Harlem Railroad and between Jerome and Webster Avenues, stretches a magnificent ridge extending all the way to Mosholu Parkway at Van Cortlandt Park, a distance of four and one-quarter (4 ¼) miles.

No investments made by a municipality pay such large returns as improvements which attract visitors. Crowds of pleasures seekers would be far more eager to see a Boulevard like the one projected than they would to see the Parks to which the Boulevard would lead.

No time should be lost in doing at once that which must be done hereafter, if not at the present time. Even the suggestion of the Boulevard raises real estate values; the longer the Boulevard is postponed the more it will cost. The City cannot acquire the necessary land too quickly.

The advantage of the Boulevard is made most apparent by the simple fact that the very moment the official map, of which the Boulevard is a feature, is adopted, real estate values in the area benefited by the improvements will approximately increase as follows:

$1,500 each, or $2,139,000.00
1,280 Lots on the approaches will increase $1,000 each, or 1,280,000.00
12,144 Lots between Jerome Ave. and Webster Ave. will increase $300 each, or $3,643,200.00

The assessed value of all lots lying between Jerome Avenue and Webster Avenue, and from Cedar Park to Mosholu Parkway, as given in the latest assessment books in the Tax Department, is:

In the 23rd Ward $2,356,400.00
In the 24th Ward $4,718,999.00

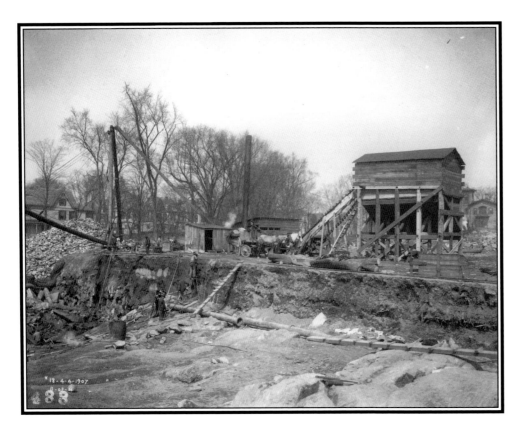

CONSTRUCTION OF THE GRAND BOULEVARD & CONCOURSE
Photographer unknown
The Bronx County Historical Society Collections

[opposite page]
CONSTRUCTION OF THE GRAND BOULEVARD & CONCOURSE
Photographer unknown
The Bronx County Historical Society Collections

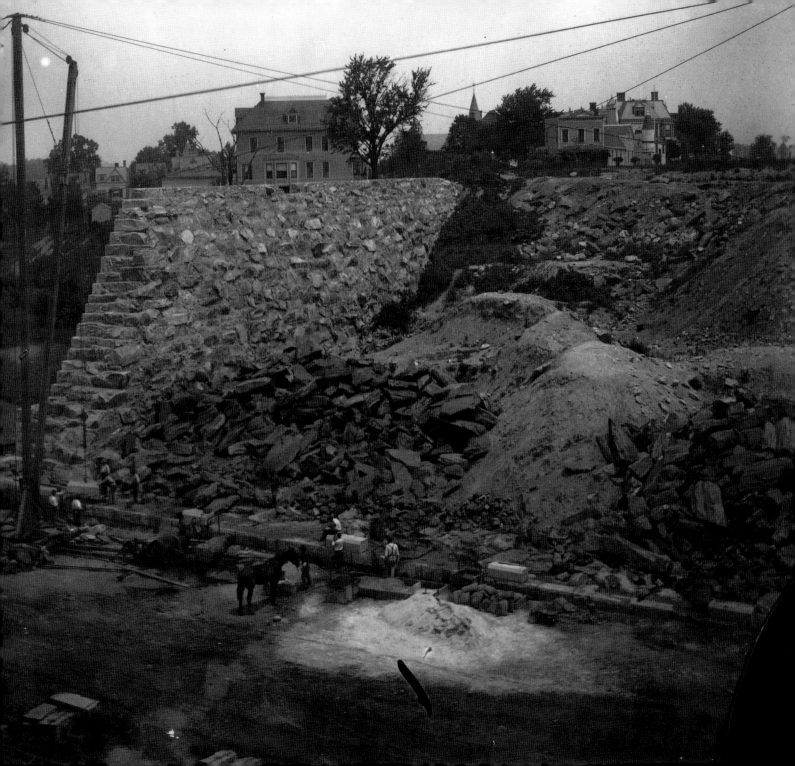

The great cost involved in the creation of a Grand Boulevard, 182 feet wide, is too great to be undertaken for anything that will not be perpetual. Such a thoroughfare must be sufficiently elevated to give a commanding view in all directions, and the ridge, which is the line of the projected Boulevard, with respect to its beauty, has no parallel either in Europe or America.

It must be retained by making it a Boulevard or cut away and destroyed by running streets through it upon the grade required by the adjacent sections; to retain it means an enormous profit to the City treasury and property owners; to destroy it involves an enormous expenditure of money in cutting through high hills.

A boulevard once established must be secure forever against the intrusion of trade. This result is obtained by running important cross-town streets under the Boulevard, which is made accessible by approaches on either side from the parallel avenues.

The transverse roads occupy the central strip of the streets, on each side of which are exterior strips upon the proper a grade of the street and affording access to the abutting lots and residences thereon.

The Boulevard can thus be reached at every intersecting street by all desiring to walk or drive upon it.

Its great width and ample provision for every kind of demand that can be made upon its space, from walking to speeding, make it perfectly adapted to all the purposes for which a boulevard can be utilized.

It is a Boulevard, a promenade, a succession of parks, a driveway, and a speedway all at the same time. Various are the purposes which it will serve.

The projected Boulevard, serves each and all of them to perfection. It will be forever secure against the invasion of trade because the conditions upon which trade thrives are lacking and will be lacking as long as the Grand Boulevard and Concourse continues.

The Boulevard will have an almost level roadway and the "ridge" presents the only spot within the limits of the city where cross streets running under it can be constructed.

The Grand Boulevard and Concourse is illustrated by the following maps:

Exhibit A. Map showing the location of the Grand Boulevard and Concourse and the street system Westerly of the New York and Harlem Railroad from Cedar Park to Van Cortlandt Park
Exhibit B. Plan and profile of the proposed Boulevard and Concourse from Jerome Avenue at the junction of the approach to the new Macomb's Dam Bridge to Mosholu Parkway

Exhibit C. Section through a transverse road under the Grand Boulevard and Concourse

Exhibit D. Birdseye view of the proposed Boulevard and Concourse in the 23rd and 24th Wards

Exhibit E. Perspective view of the crossing of one of the transverse roads under the Grand Boulevard and Concourse

Exhibit F. Perspective view in the line of the Grand Boulevard and Concourse, showing divisions of roadways, drives and walks

Exhibit G. Map of the City of New York showing location of the Grand Boulevard and Concourse

Respectfully submitted,

LOUIS A. RISSE,
Chief Engineer.
Office of Commissioner of Street Improvements, 23rd and 24th Wards

The maps showing the new street system, with the Grand Boulevard and Concourse laid out as a feature, were submitted to the Board of Street Opening and Improvement, by whom, after several public hearings to which the people in general were invited, they were finally approved of, adopted, and were ordered filed according to law, which was done, and which made them final and conclusive.

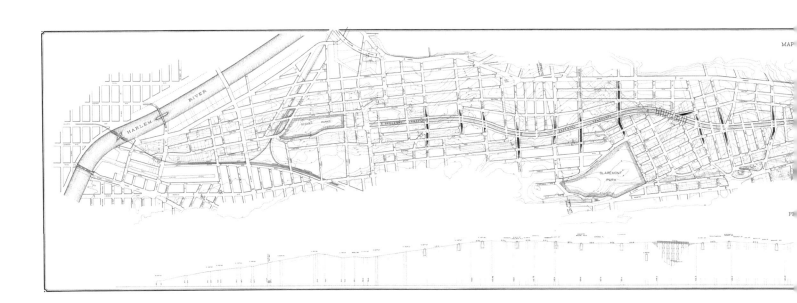

**PLAN AND PROFILE OF THE PROPOSED
SPEEDWAY CONCOURSE, AUGUST 1892**
Ink on paper
Courtesy of the Office of the Bronx Borough President

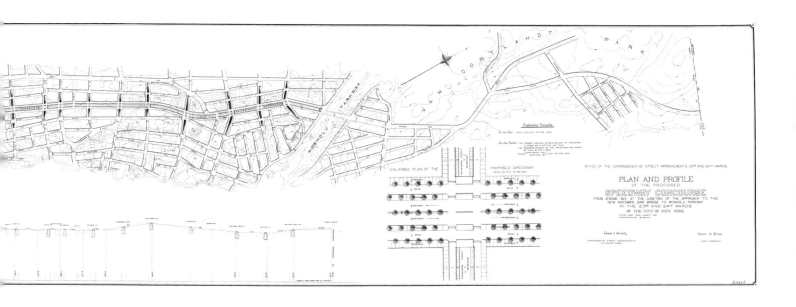

PLAN AND PROFILE
OF THE PROPOSED
SPEEDWAY CONCOURSE
FROM JEROME AVE. AT THE JUNCTION OF THE APPROACH TO THE
NEW MACOMBS DAM BRIDGE TO MOSHOLU PARKWAY
IN THE 23RD AND 24TH WARDS
OF THE CITY OF NEW YORK

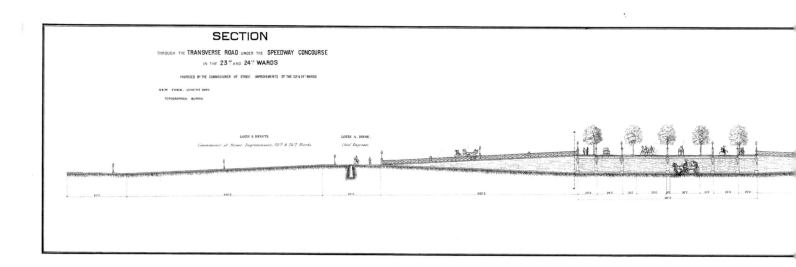

SECTION

THROUGH THE **TRANSVERSE ROAD** UNDER THE **SPEEDWAY CONCOURSE**

IN THE **23** AND **24** **WARDS**

PROPOSED BY THE COMMISSIONER OF STREET IMPROVEMENTS OF THE 23 & 24 WARDS

NEW YORK, AUGUST 1892

TOPOGRAPHICAL BUREAU.

LOUIS J. HEINTZ

Commissioner of Street Improvements, 23 & 24 Wards

LOUIS A. RISSE.

Chief Engineer.

**LONGITUDINAL SECTION THROUGH THE TRANSVERSE ROAD
UNDER THE SPEEDWAY CONCOURSE, AUGUST 1892**
Ink on paper
Courtesy of the Office of the Bronx Borough President

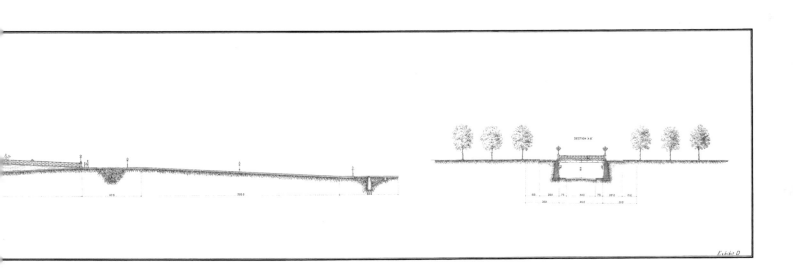

SECTION A-B

Exhibit D

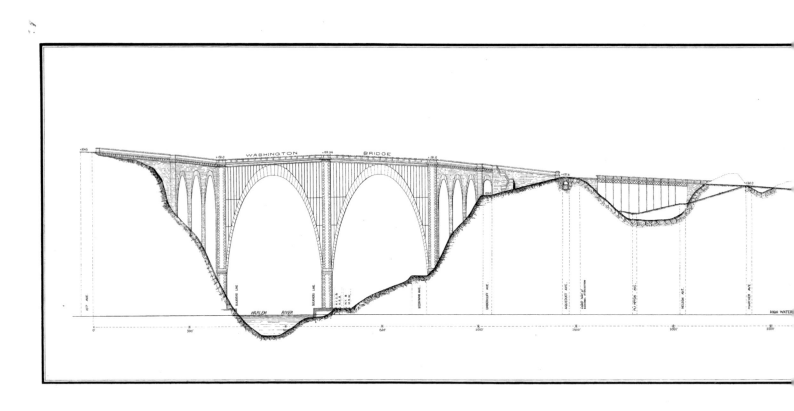

**LONGITUDINAL SECTION THROUGH
THE PROPOSED VIADUCT, AUGUST 1892**
Ink on paper
Courtesy of the Office of the Bronx Borough President

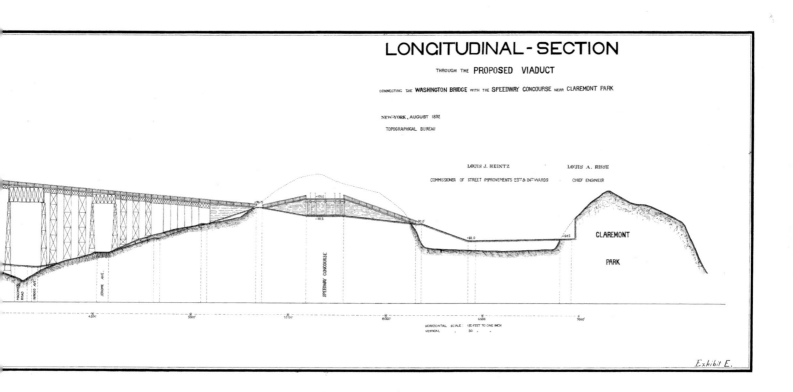

LONGITUDINAL - SECTION

THROUGH THE PROPOSED VIADUCT

CONNECTING THE WASHINGTON BRIDGE WITH THE SPEEDWAY CONCOURSE NEAR CLAREMONT PARK

NEW-YORK, AUGUST 1892

TOPOGRAPHICAL BUREAU

LOUIS J. HEINTZ

COMMISSIONER OF STREET IMPROVEMENTS 23RD & 24TH WARDS

LOUIS A. RISSE

CHIEF ENGINEER

CLAREMONT

PARK

HORIZONTAL SCALE : 150 FEET TO ONE INCH

VERTICAL " 30 " "

Exhibit E.

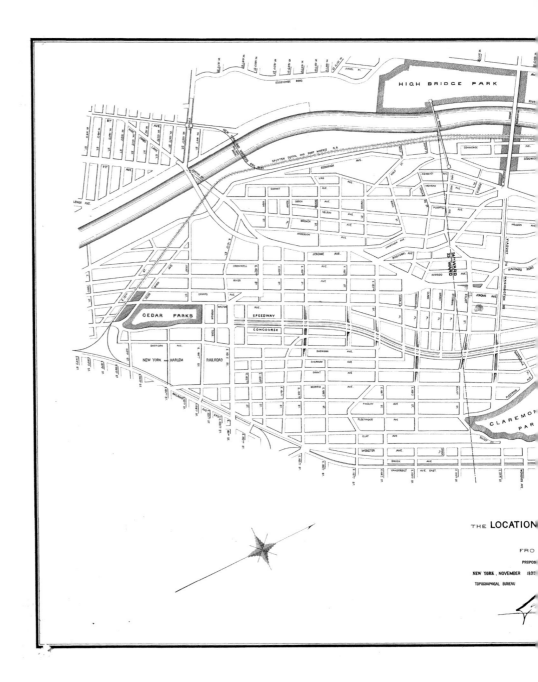

**LOCATION OF THE SPEEDWAY CONCOURSE
AND THE STREET SYSTEM, NOVEMBER 1892**
Ink on paper
Courtesy of the Office
of the Bronx Borough President

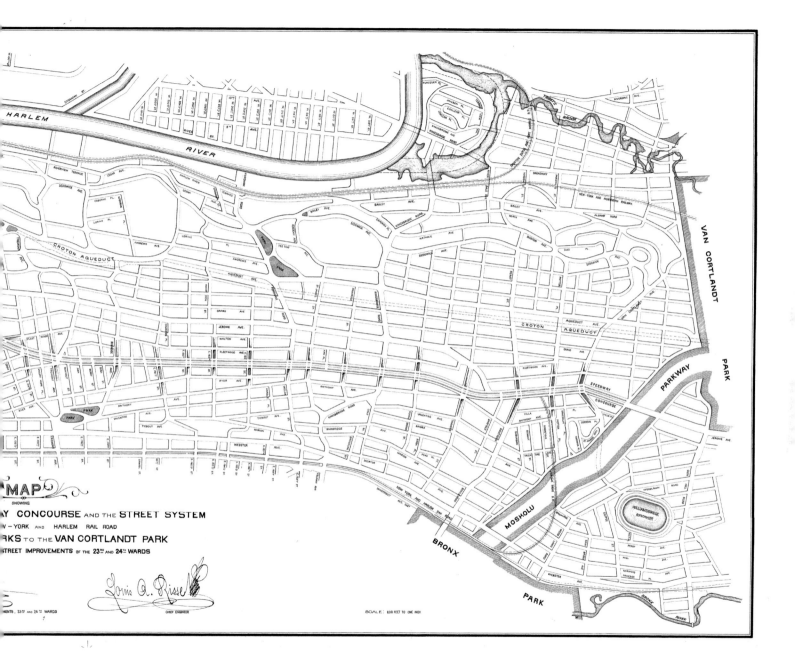

MAP
SHOWING

...AY CONCOURSE AND THE STREET SYSTEM

...W - YORK AND HARLEM RAIL ROAD

...RKS TO THE VAN CORTLANDT PARK

...STREET IMPROVEMENTS OF THE 23ᴿᴰ AND 24ᵀᴴ WARDS

CHIEF ENGINEER

...MENTS, 23ᴿᴰ AND 24ᵀᴴ WARDS

SCALE: 600 FEET TO ONE INCH

**MAP SHOWING SEWERAGE DISTRICTS,
DECEMBER 31, 1892**
Ink on paper
Courtesy of the Office of the Bronx Borough President

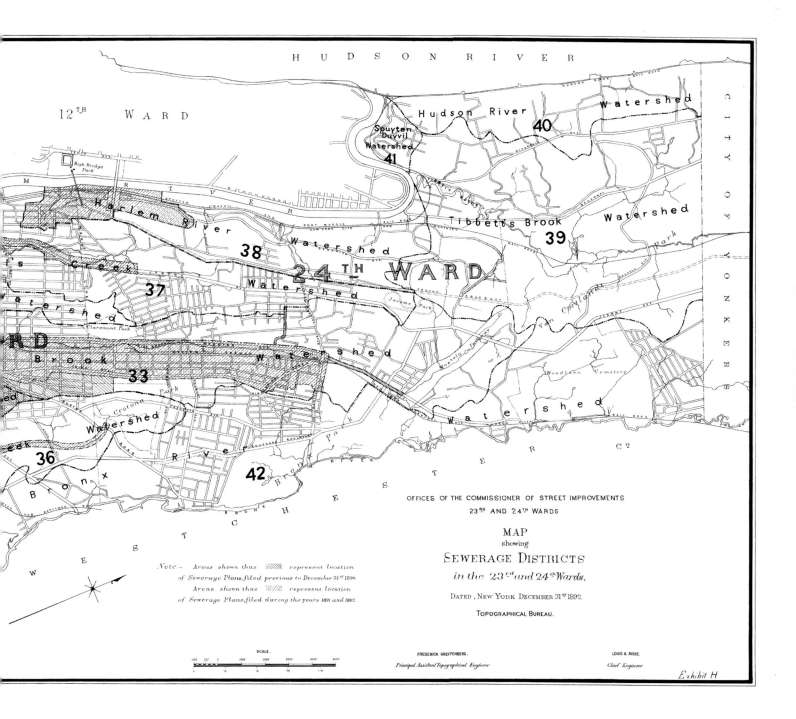

HUDSON RIVER

12TH WARD

Hudson River Watershed
40

Spuyten Duyvil Watershed
41

High Bridge Park

Harlem River

Watershed
38

24TH WARD

Watershed
37

Tibbetts Brook Watershed
39

Jerome Park

Watershed

Claremont Park

RD

Brook

33

Watershed

River

Watershed

Bronx

36

42

Bronx River

WESTCHESTER CO.

Woodlawn Cemetery

Van Cortlandt Park

CITY OF YONKERS

Note.— Areas shown thus ▨▨▨ represent location
of Sewerage Plans, filed previous to December 31st 1890.
Areas shown thus ▨▨▨ represent location
of Sewerage Plans, filed during the years 1891 and 1892.

OFFICES OF THE COMMISSIONER OF STREET IMPROVEMENTS
23RD AND 24TH WARDS

MAP
showing
SEWERAGE DISTRICTS
in the 23rd and 24th Wards.

DATED, NEW YORK DECEMBER 31st 1892.

TOPOGRAPHICAL BUREAU.

SCALE.

FREDERICK GREYFFENBERG.
Principal Assistant Topographical Engineer

LOUIS A. RISSE.
Chief Engineer

Exhibit H

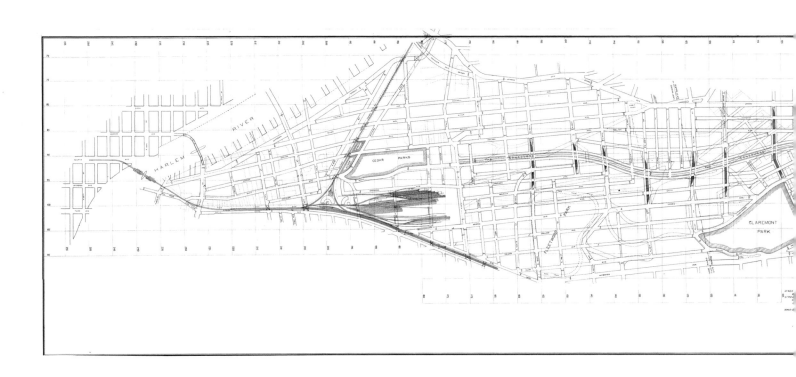

STREET SYSTEM, FEBRUARY 23, 1893
Ink on paper
Courtesy of the Office of the Bronx Borough President

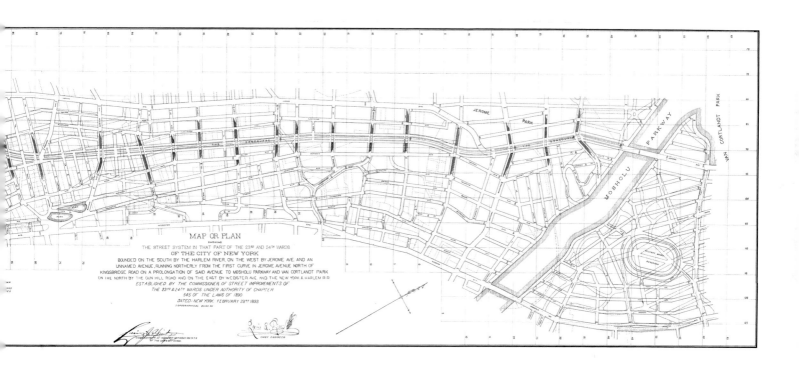

MAP OR PLAN
showing
THE STREET SYSTEM IN THAT PART OF THE 23RD AND 24TH WARDS
OF THE CITY OF NEW YORK
BOUNDED ON THE SOUTH BY THE HARLEM RIVER, ON THE WEST BY JEROME AVE. AND AN
UNNAMED AVENUE, RUNNING NORTHERLY FROM THE FIRST CURVE IN JEROME AVENUE NORTH OF
KINGSBRIDGE ROAD ON A PROLONGATION OF SAID AVENUE TO MOSHOLU PARKWAY AND VAN CORTLANDT PARK
ON THE NORTH BY THE GUN HILL ROAD AND ON THE EAST BY WEBSTER AVE. AND THE NEW YORK & HARLEM R.R.
ESTABLISHED BY THE COMMISSIONER OF STREET IMPROVEMENTS OF
THE 23RD & 24TH WARDS UNDER AUTHORITY OF CHAPTER
545 OF THE LAWS OF 1890
DATED NEW YORK, FEBRUARY 23RD 1893

BOLD VISION: LOUIS RISSE'S GRAND PLAN FOR THE CONCOURSE

Ray romley

The design and building of the Grand Concourse in the Bronx are framed within a much broader economic, geopolitical, and demographic narrative, the growth of the city of New York to become one of the largest and most important cities in the world. From a tiny Dutch colony established in 1625 at the southern tip of Manhattan, New York grew to become a global economic hub, and by the 1950s it was the center of the most populous metropolitan region in the world.[1] Though now overtaken in population by several major cities in other countries, New York is still unquestionably "a world city" of enormous importance.

Between 1790 and 1890, the population of New York City rose from just over 33,000 to over 1.5 million.[2] By 1900, with further growth and immigration, and with the incorporation of the populations of Brooklyn, Queens, Staten Island, and the East Bronx, it exceeded 3.4 million. By 1950 it was 7.89 million. Meanwhile, the population of the Bronx grew from about 89,000 in 1890 to 1.45 million in 1950. The massive growth of New York City and the population of the Bronx between the 1890s and the 1950s and the design and implementation of the Grand Concourse project that facilitated some of that growth were supported by six major projects of the nineteenth century:

First, the Commissioners' Plan of 1811, which created the basis for Manhattan's grid and the extension of the city street system from Houston Street almost to the northern tip of Manhattan.[3]

1
United Nations, *World Urbanization Prospects: The 2003 Revision* (New York: United Nations), 258–61.

2
Demographic information in this paragraph is from Ira Rosenwaike, *Population History of New York City* (Syracuse, N.Y.: Syracuse University Press, 1972).

3
John W. Reps, *The Making of Urban America* (Princeton, N.J.: Princeton University Press, 1965), 294–99.

Second, the construction of the Erie Canal, opened in 1825, which gave New York City a long-term advantage over all the other eastern seaboard cities for trade with North America's interior. The ensuing growth in commerce led to successive expansions of the canal, and also to the construction of the New York Central Railroad.[4]

Third, the construction of the Croton Dam and Aqueduct between 1837 and 1848, bringing abundant fresh potable water to Manhattan and dramatically improving public health. Quite soon, however, population growth led to water shortages, and the system bringing water to the city through the Bronx has been expanded several times, beginning with the opening of the New Croton Aqueduct in 1891.[5]

Fourth, the construction of Central Park between 1857 and 1863, giving New York City a world-ranking amenity and dramatically increasing public support for parks and outdoor recreation.[6]

Fifth, the consolidation of the Greater City of New York, starting with the Great North Side (the West Bronx) in 1874, continuing with the East Bronx in 1895, and incorporating Brooklyn, Queens, and Staten Island on January 1st 1898.[7]

Sixth, the plan for the new parks beyond the Harlem River, signed into law in 1884, creating the basis for land expropriation, landscape preparation, and the addition of 3,840 acres of parkland to the city. Four large parks were created: Van Cortlandt, Bronx, Crotona, and Pelham Bay, to be linked by the Mosholu, Crotona, and Pelham parkways; two smaller parks were also included, Claremont and St. Mary's.[8]

These six momentous changes in the nineteenth century endowed New York with the regional and international trade links necessary for economic expansion and the land and infrastructure necessary to facilitate rapid long-term urban expansion. Many additional changes were interwoven, of course, including the tenement laws; growing awareness of sanitation and public health; the expansion of educational, health care, and social service; outdoor recreation programs; and the development of the seaport and the mass transit system.

The impact of New York's great nineteenth-century projects was primarily directed northward, to ensure the full development of Manhattan island, and to develop the West Bronx as a northward expansion of Manhattan and a corridor linking Manhattan with up-state, New England, and freshwater sources. Northward expansion was easy and logical, not only because of the attractions of the Bronx and other mainland areas of New York state but also because of the disadvantages of areas to the west, east, and south. The Harlem River was narrow and easy to bridge, while the Hudson River and the East River posed major engineering problems and meant very high costs for bridge-building and tunneling. To the residents of New York City, New Jersey was a rival state, and Brooklyn, before consolidation, was a rival city. Long Island offered ample room for expansion but no obvious trade routes to more distant areas and no substantial freshwater reserves.

4
Peter L. Bernstein, *Wedding of the Waters: The Erie Canal and the Making of a Great Nation* (New York: W. W. Norton, 2006).

5
Charles H. Weidner, *Water for a City* (New Brunswick, N.J.: Rutgers University Press, 1974).

6
Roy Rosenzweig and Elizabeth Blackmar, *The Park and the People: A History of Central Park* (Ithaca, N.Y.: Cornell University Press, 1992).

7
David C. Hammack, *Power and Society* (New York: Russell Sage Foundation, 1982), 185–229.

8
John Mullaly, *The New Parks Beyond the Harlem* (New York: Record and Guide, 1887).

By the 1870s, two axes of northward expansion were clearly evident. The principal axis ran from East Harlem, up the central valley of the West Bronx, with a strip of urban development stretching from Mott Haven through Melrose, Morrisania, and Tremont, and on to Bathgate, West Farms, Belmont, and Fordham. The secondary axis ran from northern Manhattan into High Bridge, Kingsbridge, and Riverdale.[9] Transportation links were gradually expanded to parallel these developments, starting with horsecars and railroads and leading on to the construction of subways and elevated trains. Between the two axes, however, was an open ridge oriented north to south and averaging about 160 feet above sea level. This ridge was the one that Louis Risse proposed as the axis of the Grand Concourse, taking advantage of the same physical features that had made the Bronx the focus for the 1880s expansion of the New York City park system: topography, tree cover, and low population densities, all of which facilitated the creation of "natural parks"—beautiful landscaped areas at very modest cost.

Perhaps the greatest visionary for the northward expansion of New York and the incorporation of the Bronx into the city was Andrew Haswell Green (1820–1903), most notably through his work as President and Comptroller of the Central Park Commission, then Emergency City Comptroller, President of the Consolidation Inquiry Committee, and one of the drafters of the Consolidation Law of 1895.[10] Almost as central as Green to the whole process were Frederick Law Olmsted (1822–1903) and Calvert Vaux (1824–1895). Their design for Central Park incorporated a globally significant innovation: grade-separated transportation networks for freight carriages, passenger carriages, horseback riders, and pedestrians, using bridges and tunnels so as to minimize the possibility of congestion and accidents.[11] Most important of all, they sank the four transverse freight highways running west-east across the park so that city commercial traffic could run below the recreational carriage, horseback, and pedestrian flows of the park. Later, between 1868 and 1870, with pilot projects in Brooklyn and Buffalo, they developed another major innovation, the parkway, as a tree-lined boulevard leading from residential neighborhoods into parks, or connecting parks. This led directly to Olmsted's vision of a metropolitan regional park system, whereby all major city parks would be connected to one another by parkways that would also lead out of the city to the rural areas beyond.[12] To create such a system for New York, many new parkway axes were needed.

John Mullaly (1835–1915), who founded the New York Park Association in 1881, became the most important campaigner for a metropolitan regional park system. He campaigned for "the New Parks beyond the Harlem (River)," and his legislative success helped create the rationale for Risse's "great connector"—the Grand Concourse, linking the parks, grand avenues, and speedways of Manhattan with the new parks and parkways of the North Bronx. Since its formal creation in 1898, the borough of the Bronx has had the highest proportion of parkland of any of New York City's five boroughs. Mullaly summarized his parks plan for the Bronx as offering "nearly 4,000 acres of free playground

9
Eric Homberger, *The Historical Atlas of New York City* (New York: Henry Holt, 1994), 124.

10
John Foord, *The Life and Public Services of Andrew Haswell Green* (Garden City, N.Y.: Doubleday, Page & Co., 1913).

11
Charles E. Beveridge and David Schuyler, eds., *The Papers of Frederick Law Olmsted, Volume III: Creating Central Park 1857-1861* (Baltimore: Johns Hopkins University Press, 1983).

12
Charles E. Beveridge and Carolyn F. Hoffman, eds., *The Papers of Frederick Law Olmsted, Supplementary Series, Volume I: Writings on Public Parks, Parkways, and Park Systems* (Baltimore: Johns Hopkins University Press, 1997), 112-46 and 171-205.

for the people [with] abundant space for a Parade Ground, a Rifle Range, Base Ball, La-
crosse, Polo, Tennis and all athletic games; picnic and excursion parties, and nine miles
of waterfront for bathing, fishing, yachting and rowing." In the 1890s the Bronx's outdoor
recreational potential was further enhanced by the projects for the First Municipal Golf
Course in Van Cortlandt Park, and for the Zoo and Botanical Garden in Bronx Park. By
the early twentieth century, the Bronx offered the widest range of opportunities in the
five boroughs for New Yorkers seeking spacious living and outdoor recreation.

RISSE AND THE GRAND CONCOURSE

Louis Risse (1850–1925) conceived the idea of the Grand Concourse in the early 1870s,
prepared detailed plans in 1892, and watched a scaled-down version of the project being
constructed between 1902 and 1909. By the 1920s the Concourse was a prestigious
growth axis and centerpiece for the borough of the Bronx, yet what it came to be was
very different from what Risse had originally envisioned.

Risse intended the Concourse to be a Grand Boulevard, and also a speedway for
horseback riding, bicycling, and horse-drawn carriages, running along the crest of a
ridge. He envisioned the construction of Victorian-style upper-middle-class single-family
dwellings on both sides of the Concourse, widely spaced so that there would be many
opportunities for the Concourse dwellers and visitors to look across the adjacent val-
leys to the hilltops of Morrisania to the east, and northern Manhattan, Riverdale, and
northern New Jersey to the west. In Risse's view, the Concourse would merit its name
not because of the density of inhabitants in the surrounding area but because of the
number of people who would come from other areas to enjoy riding along its axis.

Risse's 1892 design for the Concourse was quickly overtaken by technologies and
events that he failed to anticipate: the invention of the automobile, the massive scale
of real estate development in and around New York City after the consolidation of the
Greater City of New York in 1898, the rapid growth of the New York City mass transit
system, and the mercurial population growth of the Bronx between the 1890s and the
1920s. His Concourse became a vital axis and a Grand Boulevard, but for cars rather
than for horse-drawn carriages, and for hundreds of thousands of Bronxites, rather than
for thousands of middle- to upper-class Manhattanites heading for the parks and parkways
of the North Bronx. In its worst moments, his Concourse became a speedway—not for
trotting, cantering, and galloping horses, but for speeding motorists.

Though Risse did not plan his Concourse for automobiles, apartment buildings, and
dense urban development, he lived long enough to see all these changes. His October 1892
cross-section sketch of the projected Concourse, with four wide roadways and three planted
medians, all dedicated to horse-drawn carriages, horseback riders, and pedestrians, was

LOUIS ALOYS RISSE

LOUIS ALOYS RISSE
Photographer unknown
The Bronx County Historical Society Collections

even crudely redrawn in the early twentieth century with the two center roadways reserved for automobiles. What Risse thought of the impact of cars and higher building densities on the Concourse we may never know. Apparently, there is no archive of his papers, and no publication that records his views toward the end of his life. Perhaps more information will come to light, but for the moment the main clue to Risse's later views is his other great project, the General Map of the City of New York exhibited at the *Exposition Universelle*, the World's Fair held in Paris in 1900, and subsequently at the South Carolina Interstate and West Indian Exposition held in Charleston, and at the Pan-American Exposition held in Buffalo.[13] The map was enormous, covering 837 square feet, and it depicted both the current spread of urban development in New York City and a projected street and open space system for all the undeveloped portions of the urban area. In his accompanying report to the Board of Public Improvements, Risse envisioned the city's population rising to 20 million, more than double its current (2009) size, and a total that would certainly require a predominance of apartment buildings, rather than single-family dwellings, in Manhattan, the Bronx, Queens, and Brooklyn. Risse described his vision for the expanded city as follows:

> Unquestionably the most interesting and imposing feature of the whole production is the tentative or proposed layout of an immense street system. This magnificent system, with its rectangular network of broad streets, diagonally intersecting boulevards, public squares and parks, canals, viaducts and bridges, and spreading areas divided up into large sections for residential and commercial purposes and systematically laid out with reference to the future requirements of large cities, in economy of construction and sanitary improvements, is in its complexity of plan and vastness of extent without a precedent in the history of civilized society.[14]

Risse shared and built upon the visions of Andrew Haswell Green, Frederick Law Olmsted, Calvert Vaux, and John Mullaly, advocating through his Concourse project and his monumental map of the Consolidated City a grid-planned city with wide streets and superimposed diagonal boulevards, with traffic circles at the intersection of boulevards, and with many parks, parkways, and sites for monuments. Both his design for the Concourse and his map of the Consolidated City were exercises in civic boosterism, seeking to build support for ambitious projects and long-term, ongoing urban expansion. His ultimate objective, without doubt, was to make New York the premier world city.

JOHN C. DE LA VERGNE, THE KEY BACKER

Most histories of the Bronx note that three men named Louis played leading roles in developing the street system of the emerging borough, and Louis A. Risse's Concourse

13
Paul E. Cohen and Robert T. Augustyn, *Manhattan in Maps 1527–1995* (New York: Rizzoli, 1997), 144–47.

14
Frederick Gutheim, "Anniversary Recalls City's Debt to Louis A. Risse, Its First Mapper," *New York Herald Tribune*, June 13th, section 6, 1 (1948).

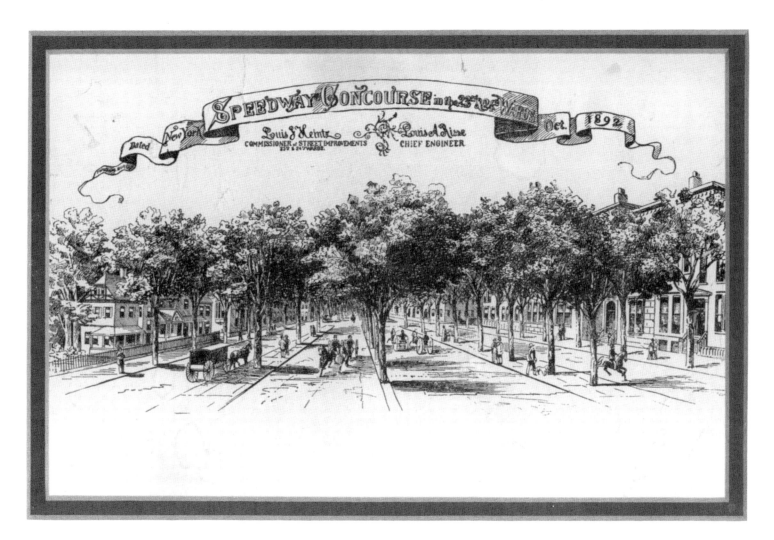

SPEEDWAY CONCOURSE, 1892
Ink on paper
Courtesy of Griffith Morris

project might never have been implemented without the involvement of the other two: Louis J. Heintz (1861–1893), who supervised Risse's design study and then died at the age of 31, and Louis F. Haffen (1854–1935), who succeeded Heintz as Commissioner of Street Improvements and went on to become the borough's first president, starting January 1st 1898, and to oversee the construction of the Concourse between 1902 and 1909. Accused of corruption in the allocation of construction contracts, Haffen was pushed out of office by Governor Charles Evans Hughes and Mayor George B. McClellan just a few weeks before the Concourse was inaugurated.[15] Because Risse had worked for Haffen, he may also have been marginalized from the inauguration by John F. Murray, Haffen's successor as borough president.

Less well known than the three engineers named Louis, but also very significant to the Concourse project, was a Bronx businessman, John C. De La Vergne (1840–1896), who, with his brother Lewis E. De La Vergne, owned and managed the De La Vergne Refrigerating Machine Company, based in Port Morris in the Bronx. John C. De La Vergne became the first president of the North Side Board of Trade (the precursor of the Bronx Board of Trade) and a leading civic booster for Bronx projects. The members of the De La Vergne family were descendants of French immigrants to the Hudson Valley region, and John gave $1,000 and helped raise another $4,000 to support Louis Risse's work in preparing the detailed plans for the Grand Concourse.[16] Subsequently, in 1894, John C. De La Vergne traveled to Albany to lobby successfully for the state legislation necessary to support the land acquisition and funding for the Concourse. In his 1894 inaugural address to the North Side Board of Trade, he praised another immigrant French engineer, Pierre Charles L'Enfant, who had prepared a plan for the new capital of the United States, Washington, D.C., in the early 1790s.[17]

Describing Washington, De La Vergne said:

Its broad streets and avenues, its numerous small parks, and the skillful arrangement of the lines of its streets make it one of the most beautiful and admired of the cities in the world.

Moving on to the Bronx, he argued,

We should be able to direct the course of development on the North Side so that eventually we will have an established business and residence community living in a city whose physical aspects will be unexcelled the world over. With the vast extent of unoccupied land in the district, as well as in that portion of Westchester County east of the Bronx, which will surely become part of our city, we have opportunities for the establishment of broad and roomy streets, venues and boulevards, which

15
Alfred Connable and Edward Silberfarb, *Tigers of Tammany* (New York: Holt, Rinehart and Winston, 1967), 245; Wallace MacFarlane, Commissioner, *Report Before the Governor of the State of New York in the Matter of Charges Preferred Against Louis F. Haffen, President of the Borough of the Bronx of the City of New York* (Albany: New York State, 1909).

16
Louis A. Risse, *The True History of the Conception and Planning of the Grand Boulevard and Concourse* (1893), reprinted in this volume.

17
John W. Reps, *Washington on View: The Nation's Capital Since 1790* (Chapel Hill: University of North Carolina Press, 1991).

should demand our earnest attention. The water front on the North, Harlem and East Rivers, and especially the latter, is a most inviting one for shipping interests… The scope of our task should be to make the North Side the most important and attractive part of the City of New York.[18]

Until his death in 1896 at the relatively young age of 55, John C. De La Vergne was a vigorous campaigner for Bronx projects, most notably the canalization of the Harlem River, new Harlem River bridges, and the Grand Concourse.[19] Nevertheless, he had interests that stretched far beyond the borough. His family were upstate landowners around the village of Esperance, west of Albany, and he was president of the Arizona Cattle Company and a director of several other corporations. In his will he named his wife and Jacob Ruppert Sr. (1842-1915), the brewing entrepreneur, as his executors. Eight days after De La Vergne's death, Jacob Ruppert Sr. was also elected president of the De La Vergne Refrigerating Machine Company.[20] The Ruppert family eventually went on to play a major role in the growth of the Bronx because Jacob Ruppert's son, Colonel Jacob Ruppert Jr. (1867-1939), became co-owner of the New York Yankees in 1915 and sole owner from 1922 till 1939. He chose to build the Yankee Stadium close to the Concourse, and he presided over the most successful team in the history of Major League Baseball.

In 1895 the De La Vergne brothers entered a car in the first long-distance automobile race ever held in the United States, the Thanksgiving Day fifty-four-mile Auto-Speed Race from Chicago to Evanston.[21] Because of a heavy snowfall, their car could not complete the race, but by involving themselves in such an event they signaled very clearly that their interest in grand boulevards went far beyond the needs of bicyclists and horse-drawn carriage riders. The De La Vergnes were automobiling pioneers, and clearly they saw the Concourse as a future automobile promenade.

There is no evidence that Louis Risse had any interest in automobile racing, but there can be little doubt that he became increasingly aware of "the horseless carriage" as he watched his Grand Concourse project move from design to reality, and as he developed his 1900 Plan for the Greater Consolidated City. The Concourse was a public works project, focusing on the boulevard axis and its underpasses, and that was what was constructed

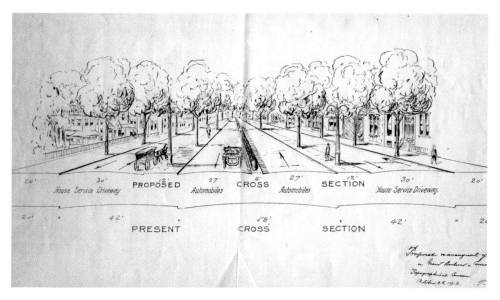

SPEEDWAY CONCOURSE, 1912
Ink on paper
The Bronx County Historical Society Collections

18
John C. De La Vergne, *Address of John C. De La Vergne, President of the North Side Board of Trade, Delivered at Its First Meeting Held at the Melrose Lyceum* (New York: North Side Board of Trade, 1894).

19
North Side Board of Trade, *In Memory of John C. De La Vergne* (New York: North Side Board of Trade, 1896).

20
Anon. "John C. De La Vergne Deceased." *Ice and Refrigeration* 10, 6 (1896): 387-8.

21
Dorothy Garven, *The Dillivans* (Los Angeles: Alder Tree Press, 1979), 37–43.

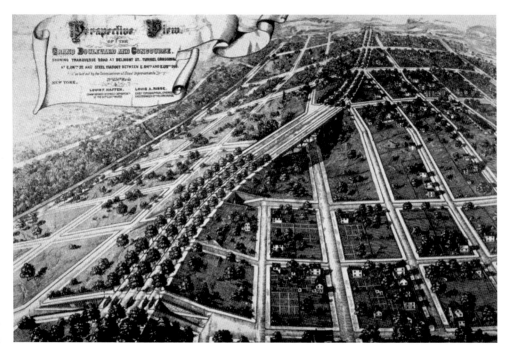

BRIDGE AT BELMONT STREET, 1875
Ink on paper
The Bronx County Historical Society Collections

between 1902 and 1909 under the general oversight of Louis F. Haffen—a sophisticated boulevard with underpasses. The project had no control over the development of the adjacent parcels of land, and no powers or funding to build the Victorian villas that Risse had fancifully sketched onto his artist's impressions of the future Concourse. Thus, in the transition from 1890s project to 1920s Concourse, the horse-drawn carriages were replaced by automobiles, and the Victorian villas were replaced by six- to nine-story apartment buildings. Risse's pioneering vision and the reality he saw in his final years were very different. The Concourse was adapted to increasing densities of population, construction, and traffic, and to a pace of urban expansion that, by the 1920s, may have exceeded the expectations of such past pioneers as Andrew Haswell Green, Frederick Law Olmsted, Calvert Vaux, John Mullaly, Louis Heintz, and John C. De La Vergne.[22]

THE MANHATTAN CONNECTION

Risse envisioned the Concourse as part of a long-distance link between Washington Square Park in Manhattan's Greenwich Village and the new Van Cortlandt, Bronx, and Pelham Bay parks. The key connecting axis was Manhattan's Fifth Avenue, which ran directly north from Washington Square Park to the southeastern corner of Central Park,

22
Evelyn Diaz Gonzalez, *The Bronx* (New York: Columbia University Press, 2004), 80–93.

and then along the east side of Central Park to Mount Morris Park (renamed Marcus Garvey Park in 1973) and on northward to the axis of the Harlem River Drive. From West 155th Street northward, that axis was soon to become the Harlem River Speedway, a custom-built three-mile axis for horseback riding and horse-drawn carriages initiated in 1892, completed in 1898, and running up to West 208th Street in Manhattan.[23] The Harlem River Speedway closely followed the west bank of the Harlem River, having a 95-foot dedicated roadway, set within an axis varying between 125 and 150 feet in width. By the 1930s, proposals were under discussion to replace the old Harlem River Drive, including the Speedway, with an automobile parkway, and that project was eventually completed in 1964. In Risse's time, however, the Speedway was "state of the art" and a key project for New York's horse-loving elite, and Risse gave it much broader significance with his vision of a seamless horse-riding and carriage connection from Washington Park all the way to the Speedway and to the Concourse and the great parks of the North Bronx. Risse may well have preferred to move all speedway activity over to the Concourse, which offered a longer axis, better views, and protection from commercial traffic crossing the axis, but he wanted the Harlem River Drive axis to serve as a boulevard to facilitate the link from Fifth Avenue to the Concourse.

From the Harlem River Drive axis to the Concourse, the key connector was the Macombs Dam Bridge, which connected Manhattan's West 155th Street to the Bronx's East 161st Street, and a short segment of East 161st Street from the river to the top of the ridge. A toll bridge at Macombs Dam had been completed in 1814, and in 1861 it was replaced by a new toll-free bridge. Eventually in 1895 the second Macombs Dam Bridge was replaced by the present structure, which has been substantially modified since its initial construction.[24]

In 1927 an alternative connection from Fifth Avenue to the Concourse emerged with the completion of the one-mile-southward extension of the Grand Concourse along the Mott Avenue axis from East 161st Street to East 138th Street in the Bronx. As a result of this project, the 138th Street (Madison Avenue) Bridge, completed in 1884 and replaced by a new bridge in 1910, became an alternative to the Macombs Dam Bridge.

Fifth Avenue was certainly a fitting complement to Risse's projected Grand Concourse. By the late nineteenth century, it was already the location of choice for elite and luxurious stores, major public institutions, mansions, and upmarket apartment houses. It was narrower than the projected Concourse over most of its length, and it did not have the street trees and planted medians featured in the designs for the Concourse and the Mosholu and Pelham Bay parkways, but it already had many impressive buildings and plenty of pedestrian traffic. Had it been reserved for horse-drawn carriages, horseback riders, bicyclists, and pedestrians, it could have served as a magnificent Grand Boulevard and Concourse for Manhattan. From Washington Park to its northern terminus at 138th

23
Anon., "Harlem River Speedway," *Scientific American*, 76, no. 6, Feb. 6, 81–2 and 89–90, and no. 7, Feb. 13, 97–98 (1897).

24
Sharon Reier, *The Bridges of New York* (New York: Quadrant Press, 1977).

Street, Fifth Avenue provides an impressive 6.75-mile corridor, and from that northern tip it was just one additional mile to the beginning of Risse's projected Concourse at 161st Street. In turn, a 4.25-mile journey up the Concourse would connect to Mosholu Parkway, and a half mile beyond was the entrance to Van Cortlandt Park. From Washington Square Park to Van Cortlandt Park would be a 12.5-mile journey, or a 25-mile round-trip, a bracing opportunity for a day-long excursion in a horse-drawn carriage.

THE SIGNIFICANCE OF RISSE'S UNDERPASSES

When Risse envisaged and designed the Concourse, grade separation was still a little-known and little-used concept. Olmsted and Vaux had pioneered the idea in their Greensward Plan for Central Park, but the Concourse was the first large-scale application of the idea to city streets in North America. By the 1920s and 1930s, grade separation became customary in designs for the superhighways of the future, but in the 1890s it was a highly innovative concept.

Risse initially envisaged 23 underpasses for the 4.25-mile Concourse axis, but he eventually was forced to cut the number to 9 so as to reduce the cost of the project.[25] His underpasses carried a high initial cost because of all the earth moving that was involved, but they brought major long-term dividends in the avoidance of accidents at grade crossings, in the reduction of congestion, in reduced effort for pedestrians and horses, and reduced fuel consumption for vehicles in ascending and descending steep slopes. In Risse's initial vision, the underpasses guaranteed the integrity of the Concourse as a south-north recreational axis, forming the spine of a residential neighborhood. It separated out the "commercial" traffic and activity that would pass east-west under the Concourse. That commercial traffic serviced the Harlem, Washington Heights, and Inwood neighborhoods of northern Manhattan; the Hudson, Harlem, and East river waterfronts; and the densely populated and industrialized areas of the Bronx along the Harlem Railroad and Third Avenue. Just as Olmsted and Vaux's four sunken transverse freight highways across Central Park linked the Hudson and East river waterfronts, Risse's underpasses linked waterfronts and facilitated trans-shipment of marine cargo, construction materials, and such bulky items as grain, beer barrels, and furniture. Without a doubt, major Bronx industries like the De La Vergne refrigeration plant and the Haffen brewery benefited from the underpasses, especially in servicing the rapidly expanding German- and Irish-American populations of northern Manhattan.

Risse's underpasses were precursors of not only twentieth-century grade separation, flyovers, underpasses, and cloverleaves but also of a twentieth-century land use planning idea—zoning—that was pioneered in New York, with the first legislation approved in 1916.[26] The aim was to separate industrial and associated commercial activities from

25
Louis A. Risse, *History in Brief of the Conception and Establishment of the Grand Boulevard and Concourse* (1897), reprinted in this volume.

26
Edward M. Bassett, *Zoning* (New York: Russell Sage Foundation, 1936).

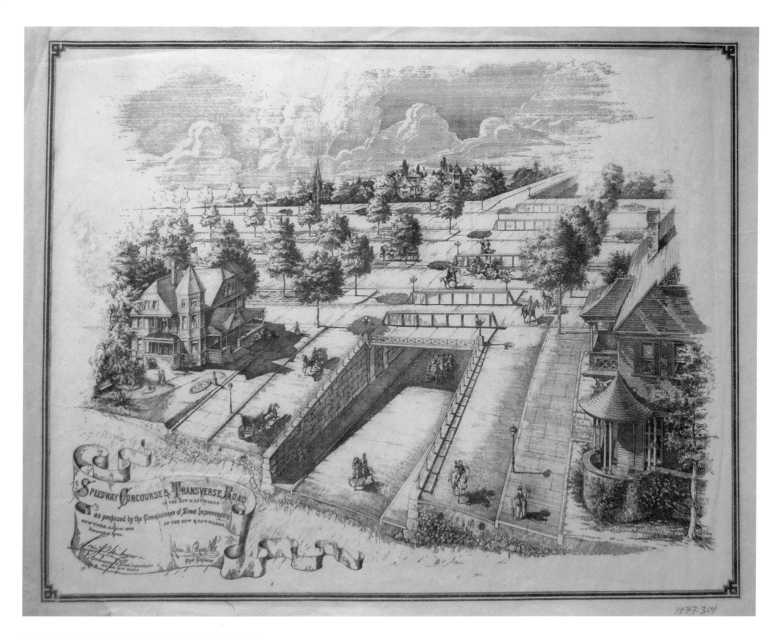

SPEEDWAY CONCOURSE AND TRANSVERSE ROAD
Ink on paper
The Bronx County Historical Society Collections

BIRDSEYE OF GRAND SPEEDWAY CONCOURSE, 1892
Ink on paper
The Bronx County Historical Society Collections

residential neighborhoods and to ensure that residential areas were adequately provided with parks, boulevards, and other amenities for healthful urban living.

RISSE'S ULTIMATE LEGACY: REWRITING THE GEOGRAPHY OF THE BRONX

If the Grand Concourse had never been conceived and built, the Bronx would still have grown rapidly between the 1890s and the 1920s, but it would have become a very different borough. The flagship project of the 1890s in many senses was the construction of the New Municipal Building, inaugurated in 1897 and renamed Borough Hall on January 1st 1898. This building was located just northwest of Crotona Park, at the intersection of Third and East Tremont avenues. The location was serviced by the Third Avenue El, the borough's first mass transit link, and it was just four short blocks from the Tremont station on the Harlem Rail Line. It was close to the center of gravity of the Bronx around 1900, a borough centered on the densely populated axis from Mott Haven to Fordham.

The Concourse project captured the imagination of the Bronx business elite, early-twentieth-century real estate developers, and hundreds of thousands of New Yorkers seeking more affordable, comfortable and spacious apartments. The new apartment buildings along the Concourse axis offered spacious accommodations along a Grand Boulevard with abundant fresh air. They seemed—and were—so much better than the crowded tenements of the Lower East Side, or those of Mott Haven, Melrose, and Bathgate, and they clearly represented upward social mobility. The result was a south-westward shift of major Bronx borough institutions toward the Concourse axis, culminating in the inauguration of the massive Bronx County Building on the Concourse in 1934, a building that for much of its life has served as a *de facto* Borough Hall. The old Borough Hall on Third Avenue was finally demolished in 1968 after suffering severe damage in a major fire, and the Concourse is now the unquestioned focus of the civic, governmental, and legal institutions of the borough.

Partly by coincidence, partly by design, most of the larger and more prestigious educational institutions in the borough have also been located within eight short blocks

of the Concourse axis. The Rose Hill Campus of St. John's College had been established in 1841, and the college was renamed Fordham University in 1907. The University Heights campus of New York University was initiated in 1891 and transferred to Bronx Community College in 1974. The new Hunter College Uptown campus was initiated beside the Jerome Park Reservoir in 1929 and transferred to the new Herbert H. Lehman College in 1968. The Bronx High School of Science was established in 1938 at 184th Street and Creston Avenue and subsequently moved in 1958 to its current location just north of Lehman College. Finally, in 1968, the new Hostos Community College was established on the southern extension of the Concourse.

A similar mix of coincidence and design led to the inauguration of two major institutions in 1923, the Concourse Plaza Hotel beside the Concourse and Yankee Stadium three blocks to the west. The tremendous success of the Yankees in the 1920s and 1930s brought prestige and hundreds of thousands of visitors to the Bronx, and the Concourse Plaza Hotel hosted many of the premier social events and most distinguished visitors. The intersection of the Concourse with East 161st Street became a key focal point for the borough, a status that was greatly enhanced by the southward extension of the Concourse to 138th Street, completed in 1927, and by the construction of the monumental Bronx County Building.

The building of the Concourse brought prestige to the Bronx and greatly enhanced civic pride. It strengthened links with Manhattan and created a new axis of development on the southwest side of the borough. The attractions of the Concourse for real estate developers and upwardly mobile New Yorkers accelerated the Bronx's development in the 1920s and 1930s. Despite having weathered the urban crises of the late 1960s and 1970s, the Concourse continues to be distinctive, attractive, and a focal axis for cultural and civic activities.

Louis Risse's visionary project has not turned out as he imagined back in the nineteenth century, but it has grandeur, it serves as a focal point for people to come together, and it has enormous potential to be further developed as a great linear public space. In the second century after its completion, the Grand Concourse could become a true Boulevard and Concourse all over again, with more greenery, street furniture, and space for pedestrians, and with designated lanes for bicycling, jogging, and inline skating. On weekends it might be closed to motor vehicles and reserved for parades, family bike excursions, marathons, and similar special events. It is a space to be filled with human activity—a meeting and gathering place for the borough's ever-changing demographic and cultural diversity. In the long run, Risse's greatest legacy may simply be the word *Concourse*—so much more sociable, pluralistic, and unusual than such commonplace names for wide thoroughfares as *Avenue* and *Boulevard*.

AN ARCHITECTURAL TOUR OF THE GRAND CONCOURSE

Francis orrone

Around the time that the first buildings appeared on the Grand Concourse, a sensitive visiting Englishman, the novelist Arnold Bennett, marveled at the Bronx. To Bennett, the apartment buildings of the Bronx were a civilizational wonder; in 1912, he wrote:

> I was urgently invited to go and see how the folk lived in the Bronx; and, feeling convinced that a place with a name so remarkable must itself be remarkable, I went. The center of the Bronx is a racket of Elevated, bordered by banks, theaters, and other places of amusement. As a spectacle it is decent, inspiring confidence but not awe, and being rather repellent to the sense of beauty. Nobody could call it impressive. Yet I departed from the Bronx very considerably impressed… I was led to a part of the Bronx where five years previously there had been six families, and where there are now over two thousand families. This was newest New York… A stout lady, whose husband was either an artisan or a clerk, I forget which, inducted me into a flat of four rooms, of which the rent was twenty-six dollars a month. She enjoyed the advantages of central heating, gas, and electricity; and among the landlord's fixtures were a refrigerator, a kitchen range, a bookcase, and a sideboard. Such amenities for the people—for the petits gens—simply do not exist in Europe; they do not even exist for the wealthy in Europe.[1]

1

Arnold Bennett, *Your United States: Impressions of a First Visit*, New York and London: Harper & Brothers Publishers, 1912, pp. 187-188.

These lines from Bennett are often quoted, although too often without context. Bennett was a highly sophisticated and knowledgeable world traveler; these lines about the Bronx are from his book *Your United States,* which in 1912 and 1913 was one of the most widely read nonfiction books in Britain and America, thus helping to establish a widely held image of the Bronx. The place with the curious name

is different. The Bronx is beginning again, at a stage earlier than art, and beginning better. It is a place for those who have learnt that physical righteousness has got to be the basis of all future progress.[2]

For many people, the Grand Concourse is the architectural showplace of the Bronx. The boulevard is renowned for its exuberant apartment buildings in the art deco style, which was popular from the late 1920s through the early 1940s. But while it's true that several wonderful art deco apartment buildings stand on the Concourse, it's also good to remember that the earliest Grand Concourse buildings were little different from those Arnold Bennett toured in Morrisania. For example, between 167th and 171st streets are three apartment complexes built in 1916–17, during what we may call, borrowing from Bennett, the Bronx's "stage earlier than art." These complexes are 1220, 1228, 1236, and 1244 Grand Concourse, between 167th and 168th streets, designed by Charles B. Meyers; 1400 and 1410, between 170th and 171st streets, designed by Irving Margon; and 1403, 1411, and 1417, also between 170th and 171st streets, designed by George and Edward Blum. None of them will turn the head of a passerby. Each is a simple brick mass with minimal ornamentation, five stories high, and sporting the simplest of arched entrances, not even hinting at art. They were all also designed by successful practitioners of the time.

Meyers, Margon, and the Blums all designed many buildings, of greater or lesser artistic ambition, throughout New York City between the 1910s and the 1940s. Meyers's notable works include the main building of Yeshiva University (1928) on Amsterdam Avenue at 187th Street and Congregation Rodeph Sholom (1928–30) at 7 West 83rd Street, both in Manhattan; he returned to the Grand Concourse in 1942 to design Lebanon Hospital at Mount Eden Avenue. Margon, with Adolph Holder, designed the

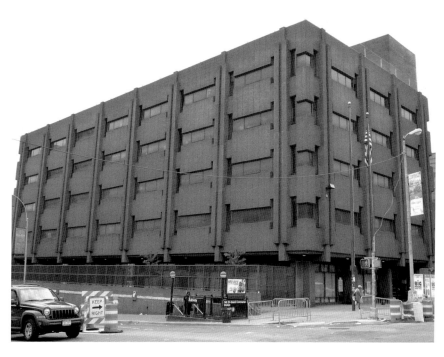

HORACE GINSBERN
Originally Security Mutual Insurance Company, now part of Hostos Community College, 1966
Southeast corner of 149th Street
Digital photograph by Edward A. Toran, 2009

2
Bennett, p. 190

famous Eldorado apartments on Central Park West at 90th Street in Manhattan. The firm of Margon & Glaser designed the Concourse Centre of Israel synagogue (1921–24) at 183rd Street and the apartment building at 2665 Grand Concourse (1922) at Kingsbridge Road; later, Margon designed the art deco apartment building at 2805 Grand Concourse (1936) between 196th and 197th streets. George and Edward Blum were prolific architects of apartment buildings in New York City, including Gramercy House (1929–30), an art deco apartment building on 22nd Street at Second Avenue in Manhattan; they also designed the famous Hotel Theresa (1912–13), the "Waldorf-Astoria of Harlem," on Adam Clayton Powell Jr. Boulevard at West 125th Street.

It is curious that the early builders on the Grand Concourse did not take aesthetic advantage of the marvelous setting with which Louis Risse, the engineer who designed the Grand Concourse, had provided them. But if the Bronx was at "a stage earlier than art," no one seems to have told Risse, and eventually his magnificent boulevard was fitted out with a beguiling assortment of buildings. Probably the best way to give the architectural flavor of the boulevard is to tour it from south to north, starting at 144th Street.

At 425 Grand Concourse, between 144th and 146th streets, stands Public School 31, built in 1897–99; it was designated as a New York City landmark in 1986. Its architect, C.B.J. Snyder, served as Superintendent of School Buildings for the New York City Board of Education between 1891 and 1923. At first the board was responsible for just Manhattan and a portion of the Bronx, but after the consolidation of Greater New York in 1898, Snyder became responsible for school buildings in all five boroughs. Little is known of his background, but he was a highly inventive architect. His school buildings are as much a defining feature of the cityscape of New York as are brownstones, tenements, and skyscrapers. He had a rare ability to pack amenities into his schools, which were often built on small or awkward sites; he provided the maximum possible amounts of light, ventilation, and recreational space. Just as important, he believed public schools should be major neighborhood landmarks, and all his buildings have sophisticated designs and distinctive skylines profiles. At Public School 31, he used the "collegiate Gothic" style with an adeptly handled profusion of Flemish gables, turrets, projecting bays, and elaborately mullioned windows. Snyder often exhibited a lightness of touch, a sure sense of not going too far with anything, that was unequaled in the work of many of the major, highly touted architects of his time. His school buildings are the repositories of more memories and dreams than perhaps any other buildings in the city.

A very different kind of school architecture can be seen between 144th and 149th streets, where one finds the campus of Hostos Community College, part of the City University of New York. A sleek metallic aerial bridge just north of 146th Street, with the college's name spelled out in bright blue lettering, is a highly visible neighborhood landmark and a symbolic gateway to the Grand Concourse. The bridge extends eastward

over the boulevard from the college's Allied Health Complex, a finely detailed building in which a superstructure of light brown brick with white horizontal accents frames deeply inset windows. Designed by Voorsanger & Mills and built in 1991, this structure possesses the kind of masonry solidity, with traditional accents, that characterizes a strain of what in the 1980s was called "post-modernism."

On the east side of the boulevard, the bridge leads to another, similarly patterned brick structure, the East Academic Complex of 1994, designed by the renowned modernist firm Gwathmey Siegel & Associates working with Sanchez & Figueroa. This eastern building also sports a zigzagging façade that pays homage to similar forms in several of the classic art deco apartment buildings farther up the Grand Concourse. In the way their brick frames project outward from the buildings' banked windows, both the western and eastern structures also seem to pay homage to the Hostos building at the southeast corner of 149th Street, a modernist building with an exposed, free-floating concrete grid framing strips of windows. Built in 1966 as the home of the Security Mutual Insurance Company, it was designed by the highly inventive modernist architect Horace Ginsbern, whose 1930s apartment buildings—including the remarkable 1150 Grand Concourse—can be found farther north on the boulevard.

On the east side of the Grand Concourse, between 149th and 150th streets, is the Bronx Post Office, designed by Thomas Harlan Ellett and built in 1935–37; it was designated as a city landmark in 1976. This elegantly simple structure, set back from the sidewalk on a balustraded terrace, faces the Concourse with seven slenderly proportioned multi-paned arched windows, which are nearly as high as the low, horizontal building and are set in simple white stone frames, accented by frames of brick patterned at angles to the brickwork of the main façade. The three central windows contain at their bases the central entrances to the Post Office. To either side of this trio are two relief sculptures in white stone. One of them, *The Letter,* is by Henry Kreis. The other, *Noah,* is by Charles Rudy. Inside are thirteen murals by the important Lithuanian-born twentieth-century American artist Ben Shahn and his wife, Bernarda Bryson. The building and its artworks form a distinguished example of Depression-era government-sponsored design.

In the 1920s, a grand classicism, richly embellished with strongly three-dimensional ornamentation and decoration, yielded to the more shallowly, but equally exuberantly, ornamental forms of art deco. In the more austere period of the Great Depression and World War II, both styles found muted echoes in the infinitely plainer, soberly stately forms of what is sometimes called "stripped classical." At the southeast corner of 153rd Street another school building, Cardinal Hayes High School, designed by Eggers & Higgins—one of the outstanding New York architectural firms of the 1940s and '50s—and built in 1941, is an excellent example of the "stripped classical" style. This superbly designed building conforms to its unusual, curving site, opposite Franz Sigel Park, with a sweep-

EGGERS & HIGGINS, ARCHITECTS
Cardinal Hayes High School, 1941
Southeast corner of 153rd Street
Digital photograph by Edward A. Toran, 2009

ANDREW J. THOMAS
Thomas Garden Apartments, 1926-27
Grand Concourse between 158th and 159th Streets
Digital photograph by Edward A. Toran, 2009

ingly convex façade that has a strong stylistic affinity to Ellett's Bronx Post Office. The convex central section of the high school is powerfully bookended by higher blocks, or "pavilions," vertically accentuated in molded brickwork. At around the same time, the firm of Eggers & Higgins was also engaged in completing the last major projects of the great American architect John Russell Pope—the Jefferson Memorial and the National Gallery of Art, both in Washington, D.C. In New York, Eggers & Higgins later produced such outstanding postwar buildings as the Church of Our Lady of Victory (1947) at 60 William Street in lower Manhattan and Vanderbilt Hall (1952) of New York University, on Washington Square South in Greenwich Village. Notable Cardinal Hayes alumni include the late comedian George Carlin and the film director Martin Scorsese.

Thus far, we have yet to see any art deco, but that changes in the block between 155th and 156th streets. Three six-story apartment buildings—numbers 730, 740, and 750—on the east side of the Concourse are very similar to one another, although 750 is the largest and most fully worked out. Numbers 730 and 740 date from 1937–39; 750 is from 1936–37. They were designed by the Russian-born Jacob M. Felson, who is represented by several other works on the Grand Concourse. In none of these do we see the elaborate ornamentation often associated with art deco; nevertheless, the simple but vigorous interplay of vertical and horizontal lines immediately identifies one strain of the style. All of the buildings feature corner cantilever windows, employed with special gusto at 750. In the block to the north, at 760, we see Felson in a different and earlier mood. This six-story apartment building has classical embellishments, with rusticated bases, heavy window enframements, ornamental brackets, emphatic belt courses, and delicately detailed pediments surmounting the end bays of each of its two halves on either side of a deep courtyard entrance.

There is a tendency to think of the "classic" Grand Concourse apartment building as being pre-war, but major apartment complexes continued to rise on the boulevard as late as the early 1960s, indicating that developers had no inklings of the social upheavals soon to bring major demographic changes to the boulevard. At the southeast corner of 158th Street is a massive apartment complex from 1953–55. Designed by H. I. Feldman in a modernist style, the building has no ornamentation, although the façades are enlivened somewhat by strong horizontals in patterned brickwork.

We now enter upon the best-known portion of the Grand Concourse, containing many of the boulevard's signature buildings. The variety is remarkable, yet nothing here seems even remotely as though it does not belong on the Grand Concourse—a phenomenon that is always a quality of great places. On the east side between 158th and 159th streets stands the Thomas Garden Apartments of 1926–27. This complex was designed by and named for Andrew J. Thomas, one of New York's most innovative architects; it was funded as an experiment in housing by John D. Rockefeller Jr.

(Thomas's Paul Laurence Dunbar Apartments, also funded by Rockefeller, were built in the same years on Seventh Avenue between 149th and 150th streets in Harlem.) Thomas, whose name is not as well known today as it should be, wanted to bring to New Yorkers of moderate means the amenities of light and air that were enjoyed by the well-to-do who lived in such places as the great courtyard apartment complexes of the Upper West Side of Manhattan, as well as by the residents of such "model tenement" complexes as the Riverside Buildings (1890) in Brooklyn Heights and the East River Homes (later Cherokee Apartments, 1911) on East 77th Street in Manhattan. Thomas is best known for his remarkable garden-apartment complexes—such as the Château (1922) and the Towers (1923–25—in Jackson Heights, Queens.

As the only complex named for Thomas, the Thomas Garden Apartments on the Grand Concourse has a special place in his body of work. The complex occupies the entire square block bounded by the Grand Concourse, 158th and 159th streets, and Concourse Village West (formerly Sheridan Avenue). It was conceived as a nonprofit cooperative (its residents could not make a profit on the sale of their apartments), and Rockefeller agreed to a maximum 6 percent return on his investment in the project. The brown-brick façades of the five-story complex are somewhat unprepossessing, but the interior courtyard garden, which was designed to be visible from within the apartments (and to be used by their inhabitants), was given a Japanese garden design with bridges, pagodas, and lanterns that still remain intact. Much of this can be viewed from the Grand Concourse through a black iron fence.

At the southeast corner of 161st Street stands 888 Grand Concourse, designed by Emery Roth and built in 1937. Roth was a Hungarian immigrant who became a specialist in apartment-building design. One of his first major works was the Hotel Belleclaire on Broadway at 70th Street, in Manhattan, built in 1901–03. By 1937, when 888 Grand Concourse was built, Roth was the preeminent apartment-building architect in New York, having created such buildings as the San Remo (1929–30) and the Majestic (1930–31), both on Central Park West in Manhattan.

At 888 Grand Concourse, Roth created a complexly massed and stylishly accented six-story building of light brick with contrasting gray terra cotta. It faces diagonally to the northwest across the Concourse toward the verdant expanse of Joyce Kilmer Park (formerly called Concourse Plaza, and extending from 161st to 164th street and Grand Concourse to Walton Avenue). The building's most defining feature is its circular entrance facing toward the intersection of the Grand Concourse and 161st Street. The circular canopy is outlined in thin metal bands and has a ceiling bearing an elaborate mosaic. The curving walls are of a golden-hued brick with banded accents of vibrant gold. A double frame—one of gold, one of black and white checks—surrounds the doorway. For good measure, there is even a circular frieze of stylized triglyphs and metopes. The whole thing

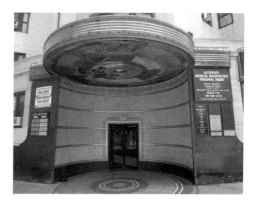

EMERY ROTH
Entrance of 880 Grand Concourse, 1937
Southeast corner of 161st Street
Digital photograph by Edward A. Toran, 2009

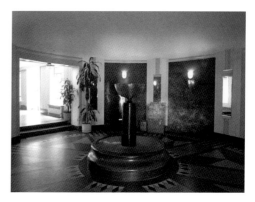

EMERY ROTH
Lobby of 880 Grand Concourse, 1937
Southeast corner of 161st Street
Digital photograph by Edward A. Toran, 2009

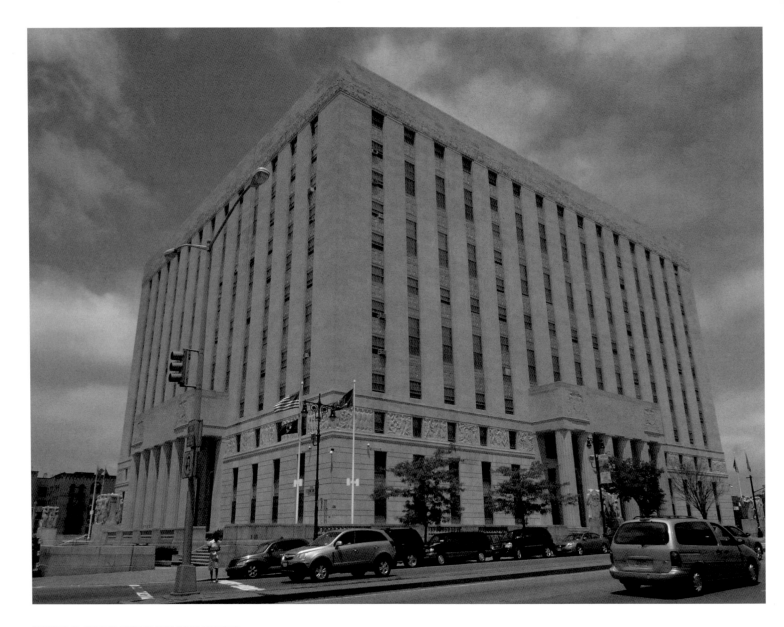

JOSEPH H. FREEDLANDER AND MAX HAUSLE
Bronx County Building, 1931-35
Southwest corner of 161st Street
Digital photograph by Edward A. Toran, 2009

seems to have come straight off the set of a Fred Astaire and Ginger Rogers movie.

With 888 Grand Concourse, the Bronx County Building, the Concourse Plaza Hotel, and Joyce Kilmer Park, the intersection of the Grand Concourse and 161st Street can claim to be the heart of the Grand Concourse—and perhaps the civic heart of the Bronx.

The Bronx County Building, on the southwest corner, was built in 1931–35 and designated in 1976 as a New York City landmark. The architects were Joseph H.

A.A. WEINMAN
Sculptures for the Bronx County Building, 1931-35
Grand Concourse and 161st Street
Digital photograph by Edward A. Toran, 2009

Freedlander and Max Hausle. The building is splendidly set off by the green spaces of Joyce Kilmer Park to the north and Franz Sigel Park (extending from 152nd to 158th street and Grand Concourse to Walton Avenue) to the south. The county building occupies the full area bounded by 158th and 161st streets and the Grand Concourse and Walton Avenue. Co-architect Freedlander, whose credits include the Museum of the City of New York (1928–30) on Fifth Avenue between 103rd and 104th streets in Manhattan, was also a co-architect of the Andrew Freedman Home on the Grand Concourse at 166th Street.

The Bronx County Building is a somber but handsome boxy structure with some ancient Greek details and the solid, trabeated mass of ancient Greek architecture. It is enlivened by ornamentation, such as the gold-patinated spandrels running up the elevations, and a decorative frieze by the well-known sculptor Charles Keck. The boxy stone sculptures set in the building's elevated, balustraded terrace feature reliefs by the notable German-born sculptor Adolph Alexander Weinman, famous for his statue of Civic Fame atop McKim, Mead & White's Municipal Building on Centre Street in Manhattan's Civic Center. The reliefs bear allegorical images relating to the history of the law. Inside the building's first floor are fascinating murals relating scenes from Bronx history, by J. Monroe Hewlett, a notable American architect and muralist who was part of the team that produced the Sky Ceiling of the Main Concourse of Grand Central Terminal in Manhattan. (Hewlett was also the father-in-law of the visionary designer R. Buckminster Fuller.) The Bronx County Building, freestanding upon a terrace with grand stairways, is the most prominent building on the Grand Concourse and has remained the seat of borough government for three-quarters of a century.

The Concourse Plaza Hotel, on the northeast corner of the Grand Concourse and 161st Street, was designed by the prolific firm of Maynicke & Franke and built in 1922–23. The eleven-story hotel is another very prominent building on the Grand Concourse: a light-colored stone base yields to a red-brick shaft that rises to classical

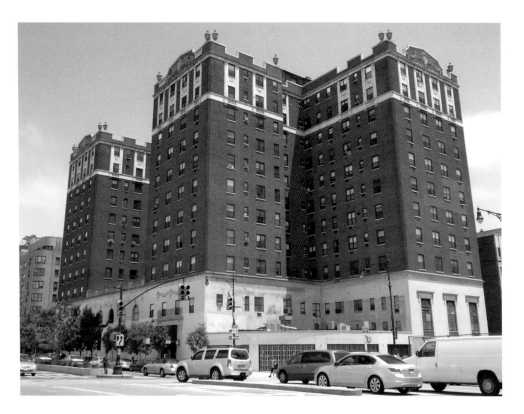

MAYNICKE & FRANKE, ARCHITECTS
Concourse Plaza Hotel, 1921-23
Northeast corner of the Grand Concourse
and 161st Street
Digital photograph by Edward A. Toran, 2009

[opposite page]
ERNST HERTER
Lorelei Fountain (Heinrich Heine Memorial),
dedicated in 1899
Joyce Kilmer Park
Digital photograph by Edward A. Toran, 2009

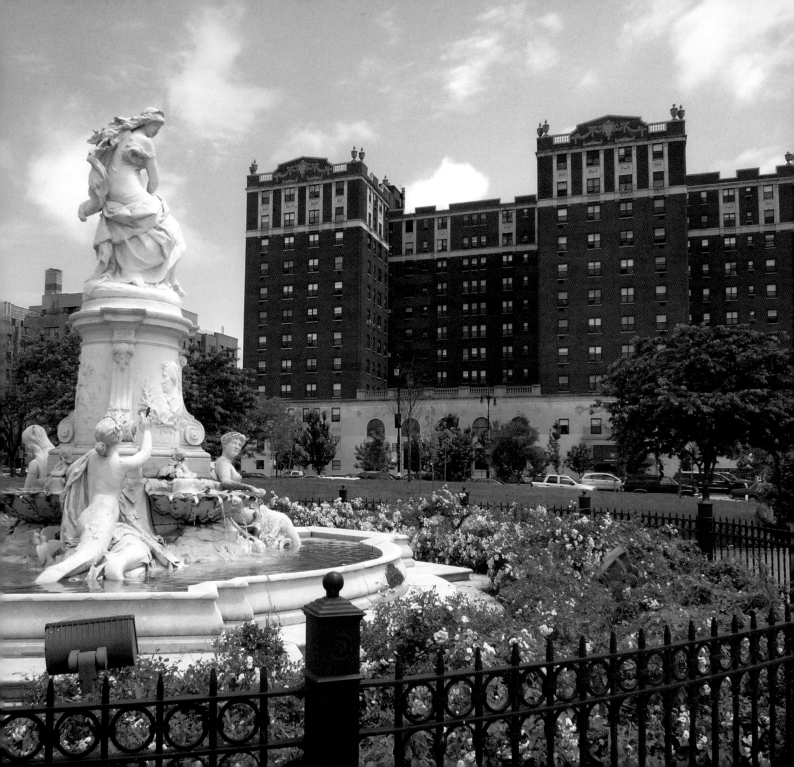

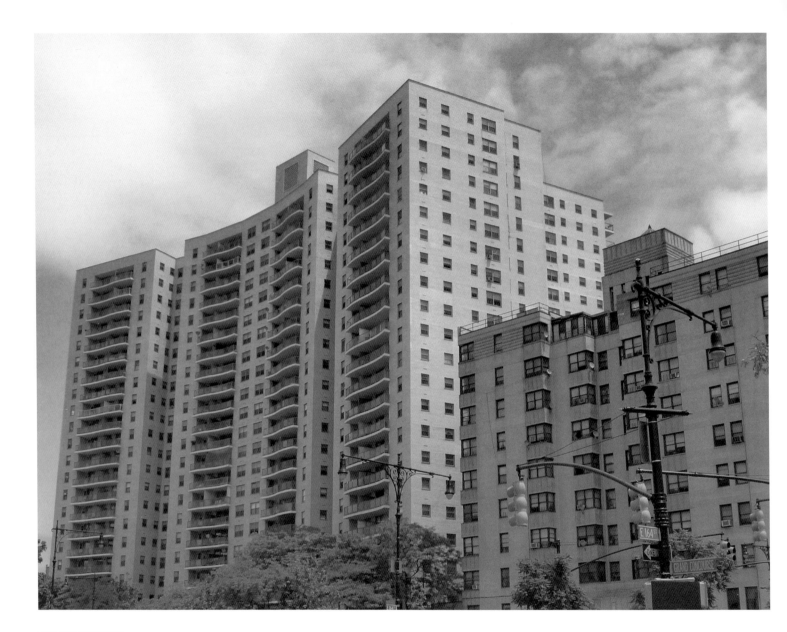

PHILIP BIRNBAUM
Executive Towers apartments
1014 Grand Concourse, 1963
Digital photograph by Edward A. Toran, 2009

ornamentation at the roofline. Of particular note are fine paired corner urns that register nicely against the broad Bronx sky. It is not its architecture, however, that makes this building a major Bronx landmark, but rather its social role as the setting of so many middle-class Bronx residents' important gatherings of family, friends, and business associates through the years. It was also the hotel that in its halcyon days (it later served as a welfare hotel) was favored by major-league baseball players: The original Yankee Stadium was just to the west on 161st Street.

Between 162nd and 163rd streets stands 930 Grand Concourse, an eleven-story apartment building designed by H. Herbert Lilien and built in 1944–48. This and 1000 Grand Concourse, between 164th and 165th streets, which was designed by Sugarman & Berger and built in 1935, are spare, modernistic buildings notable for their corner cantilever windows, once a highly desired feature of Grand Concourse apartment buildings. (Sugarman & Berger were also the architects of the forty-three–story New Yorker Hotel, which when it opened in 1930 on Eighth Avenue between 34th and 35th streets in Manhattan was the largest hotel in New York.) Between 163rd and 164th streets are 940 and 960 Grand Concourse, designed by Springsteen & Goldhammer and built in 1927, before art deco had migrated to the Grand Concourse: their style is a sort of Mediterranean/ Moorish. Springsteen & Goldhammer are known principally for their design of cooperative workers' housing, such as the Amalgamated Houses (1927) on Van Cortlandt Park South.

Another outstanding cluster of Grand Concourse buildings can be found in the two blocks between 165th and McClellan streets. At the southeast corner of 165th Street stands one of the most prominent apartment buildings in the Bronx. Executive Towers, as 1014 Grand Concourse is named, was built in 1963. It was not included in the National Register district of 1987 because it had been built too recently for "historic" status; in addition, its modernist white-brick style—inaugurated in 1950 in Skidmore, Owings & Merrill's Manhattan House apartments on East 63rd Street in Manhattan and later given a number of kitschy flourishes inspired by the works of such architects as Morris Lapidus—quickly became a kind of cliché disparaged by those of sophisticated tastes. In recent years, however, the style has gained fans, and we now appreciate the considerable virtues—including a structural panache at odds with the prevailing austerities of orthodox modernist architecture—of buildings such as Executive Towers. Its architect, Philip Birnbaum, was a prolific New York architect, and his apartment buildings, along with white brick buildings (and similarly spirited buildings that may not actually be white) by other architects, are a defining feature of the New York cityscape. The critics may have disliked them, but those who lived in them loved them, and a builder's decision to place one on a prominent site at 165th Street in 1963 was a major statement of confidence in the future of the Grand Concourse. Executive Towers, as much as any of the Concourse's earlier buildings, exudes confidence. It has an especially notable entryway with a circular

SPRINGSTEEN & GOLDHAMMER, ARCHITECTS
940 and 960 Grand Concourse apartments, 1927
Between 163rd and 164th streets
Digital photograph by Edward A. Toran, 2009

driveway and an exuberant entrance that radiates Miami Beach glamour, with a zigzagging canopy at the top of the first-floor windows, shimmery gold panels framed by marble piers set below that canopy, and sinuous balconies covering the front of the building.

Across 165th Street is The Bronx Museum of the Arts, founded in 1971 in the Bronx County Building at 161st Street. In 1982, the museum moved to the northeast corner of the Grand Concourse and 165th Street, taking over the 1961 building vacated by the Young Israel Synagogue. (The building of a new synagogue on that site in 1961 was another statement of confidence in the future of the Grand Concourse.) The architects Castro-Blanco Piscioneri & Feder remodeled the space for the museum's purposes. In 2004–06 the dramatic extension by the Miami-based firm Arquitectonica was built. The aluminum and glass accordion-fold façade seems to have drawn inspiration from the similarly folding canopy across the front of Executive Towers in the block to the south; Arquitectonica, founded in 1977 by Bernardo Fort-Brescia and Laurinda Spear, became hugely successful in the 1980s and has since designed notable buildings all over the world. The firm was also involved in the aesthetic recovery of Miami's resort architecture, which is echoed in such buildings as Executive Towers. As difficult as it would have been for the builders of Executive Towers to believe that just a few years after their building was completed the Grand Concourse would face major social and economic upheavals, so only a few years ago would it have seemed barely conceivable that Arquitectonica would design a major building on the Grand Concourse.

On the east side of the Grand Concourse between 166th and McClellan streets stands the distinctive Bronx Family Court, designed by Rafael Viñoly Architects and built in 1997. The Uruguayan-born Viñoly founded his eponymous firm in New York in 1983 and has since become one of the most widely admired architects in America. With the Bronx Family Court and the Bronx Museum extension, the Grand Concourse has once again become a showcase of new architecture. The courthouse is an avant-garde interpretation of Grand Concourse building traditions, with horizontal banding and angled windows alluding to the boulevard's art deco buildings. What's most impressive is how surprisingly neatly Viñoly fitted the courthouse between the traditionally designed 1100 Grand Concourse apartments (1927–28, designed by Gronenberg & Leuchtag) to the south—even picking up that building's rusticated base—and 1130 Grand Concourse (1925–26, designed by Raldiris & La Velle), the former Bronx Society for the Prevention of Cruelty to Children and later the Bronx Young Men's and Young Women's Hebrew Association, to the north.

Across the Grand Concourse from the Bronx Family Court is the Andrew Freedman Home. Its name may give the impression that it is or was a private residence, but in fact it was built as a luxurious retirement home for aged gentlemen; it was endowed by Andrew Freedman, one-time owner of the New York Giants baseball team. (The Giants played their home games at the Polo Grounds, which was in Manhattan on 155th Street

ARQUITECTONICA
The Bronx Museum of the Arts, 2004-06
1040 Grand Concourse
Digital photograph by Edward A. Toran, 2009

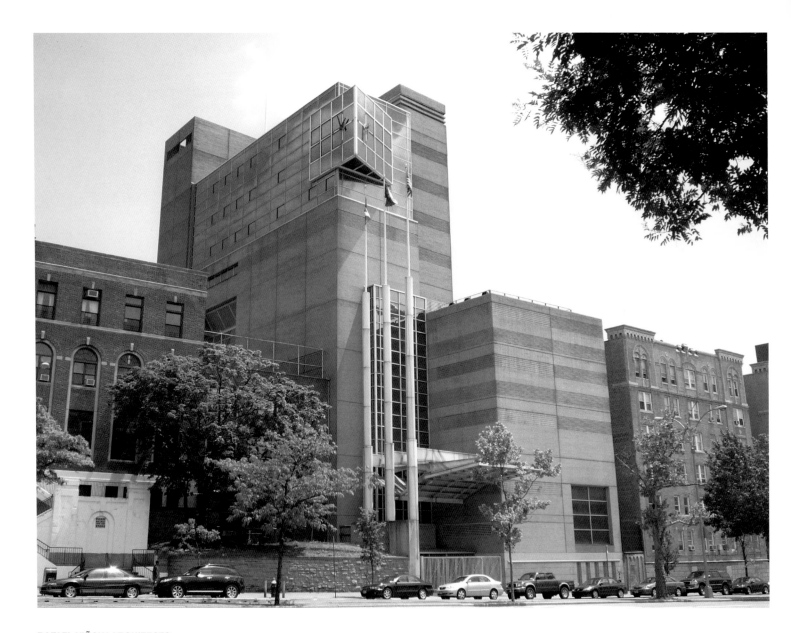

RAFAEL VIÑOLY ARCHITECTS
Bronx Family Court, 1997
Grand Concourse between 166th and McClellan streets
Digital photograph by Edward A. Toran, 2009

at Edgecombe Avenue—nearly as close to the Andrew Freedman Home as is Yankee Stadium.) Freedman wished to provide single, elderly men of refinement—doctors, lawyers, and stockbrokers—with all the comforts money could buy. To that end he hired Joseph H. Freedlander, later co-architect of the Bronx County Building, and Harry Allan Jacobs to design a superb limestone *palazzo* set back from the sidewalk behind a generous landscaped garden and a balustraded terrace. The building was completed in 1924. Freedman also hired Lucien Alavoine et Cie, perhaps the most prestigious decorating firm in the world at the time (it also decorated Manhattan's Plaza Hotel of 1907), to create the building's sumptuous interiors.

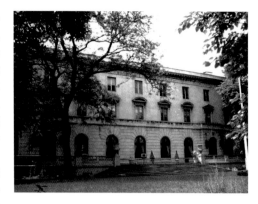

JOSEPH H. FREEDLANDER AND HARRY ALLAN JACOBS
Andrew Freedman Home, 1924
Grand Concourse between 166th and McClellan Streets
Digital photograph by Edward A. Toran, 2009

Rounding out this remarkable cluster of buildings is the apartment house at 1150 Grand Concourse, perhaps the single most astounding structure on the boulevard. Located at the northeast corner of McClellan Street, it was designed by Horace Ginsbern and built in 1936. This large six-story building has a two-hundred-foot frontage on the Grand Concourse; three wings, separated by light courts, face the boulevard. The façades are of tan brick with subtle horizontal accents in darker brick around the windows. The building's site angles sharply toward the southwest along the Concourse, which allowed Ginsbern to create dramatic angled windows framed by rounded brick piers. The building also has corner cantilever windows, some of them rounded.

A goal of some art deco designers was to convey motion, and this building does that in a very rhythmical way, reminiscent of a tight horn section in a jazz band. What really sets this building apart, however, is the treatment of its front entrance, in the central of the three wings facing the Concourse. The sweeping, curved entrance features a brown frame inset with hollowed squares as in a coffered ceiling, surrounding a large, two-part, vibrantly colored mosaic mural of marine life. Blue, silver, green, yellow, gray, and orange tiles create a heavily stylized vision of fish and aquatic vegetation, with sundry oozy, amoeba-like forms that seem inspired by surrealism. There is nothing else quite like this anywhere else in New York, and few other building details that stop passersby dead in their tracks as this mural does. It alone is worth a trip to the Grand Concourse.

Notable art deco buildings along the Grand Concourse to the north include Jacob M. Felson's 1166 Grand Concourse (1938) between McClellan and 167th streets; Felson's 1188 (1936–38) at the southeast corner of 167th Street; Horace Ginsbern's 1212 (1936–37) at the northeast corner of 167th Street; Felson's 1500 (1935) at the northeast corner of 172nd Street; H. Herbert Lilien's 1505 (1938) at the northwest corner of 172nd Street; Felson's 1675 (1936) at the southwest corner of 174th Street; Thomas Dunn's 1855 (1936) at the southwest corner of Mount Hope Place; Lilien's 1939 (1939) at the southwest corner of 178th Street; and Ginsbern's 2121 (1936) at the southwest corner of 181st Street. It may seem odd that these were all built during the Great Depression, but in fact, federal government programs to stimulate the home

construction industry led, in New York, to a mid-1930s boom in apartment-building construction. The art deco style had become popular in New York only in the late 1920s; several of these buildings, such as Felson's 1188, Dunn's 1855, and Lilien's 1939, feature jazzy, zigzagging, or serrated façades adapted to the angles in the street pattern and affording dramatic views from within.

At the southwest corner of 169th Street stands the former Temple Adath Israel (now the Grand Concourse Seventh-day Adventist Temple). It was built in 1927, and the architect is unknown; the boxy structure features a rather grand arched entrance framed by paired Corinthian columns holding up a simple entablature, on which the temple's original name is inscribed. Other noteworthy houses of worship along the Grand Concourse include the Georgian Revival Tremont Temple (1909–10) at 180th Street (now the First Union Baptist Church). The *New York Times* once described Tremont Temple as "the most prominent Reform synagogue in the Bronx and one of the best known in the city." The Colonial style may seem unusual for a synagogue, but in fact many congregations at the time wished to assert their Americanness, reminding others that Jews have been a part of American life since colonial times. Although the congregation of Tremont Temple departed the Grand Concourse for Scarsdale, New York, in 1976, the many nearby synagogues are a reminder that for many decades the Grand Concourse had a very substantial Jewish population. Another nearby synagogue building is the former Concourse Centre of Israel at 183rd Street (now the Love Gospel Assembly), designed by Margon & Glaser and built in 1921–24. This was the most prominent Orthodox synagogue on the Grand Concourse; it has a classical façade similar to that of Temple Adath Israel, with a prominent arched central section and four full-height fluted Corinthian columns.

Not all of the Concourse's religious buildings began life as the homes of Jewish congregations. At 175th Street stands the lovely and (for the Grand Concourse) anomalous Christ Congregational Church, a complexly massed red-brick structure with a white Corinthian tetrastyle portico and a white cupola. Like Tremont Temple, it was built in 1910, and conforms wonderfully to one of the many awkward corner building sites along the Grand Concourse (this intersection has six corners). The architects were Hoppin & Koen, one of New York's most prominent firms of the time; their magnificent Police Headquarters on Centre Street in Manhattan had been completed only a year before this church.

A few other interesting apartment buildings in styles other than art deco may be seen on the Grand Concourse to the north of McClellan Street. Roosevelt Gardens is a vast complex of fourteen separate structures occupying the square block bounded by 171st and 172nd streets and the Grand Concourse and Wythe Avenue. It began life in 1922–23 as the Theodore Roosevelt Apartments (Charles S. Clark, architect). By 1939 the building was owned by the Prudential Insurance Company, which hired architect J. M. Berlinger to remodel the complex; he streamlined it by removing its ornamentation.

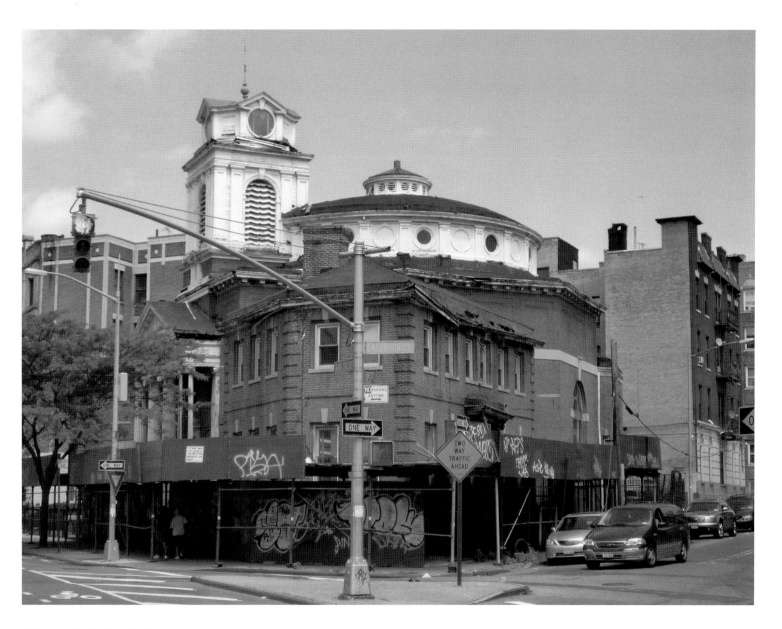

HOPPIN & KOEN, ARCHITECTS
Originally Christ Congregational Church, 1910
Grand Concourse at 175th Street
Digital photograph by Edward A. Toran, 2009

EDWARD RALDIRIS
Lewis Morris apartments building, 1923
Northwest corner of Grand Concourse and Clifford Place
Digital photograph by Edward A. Toran, 2009

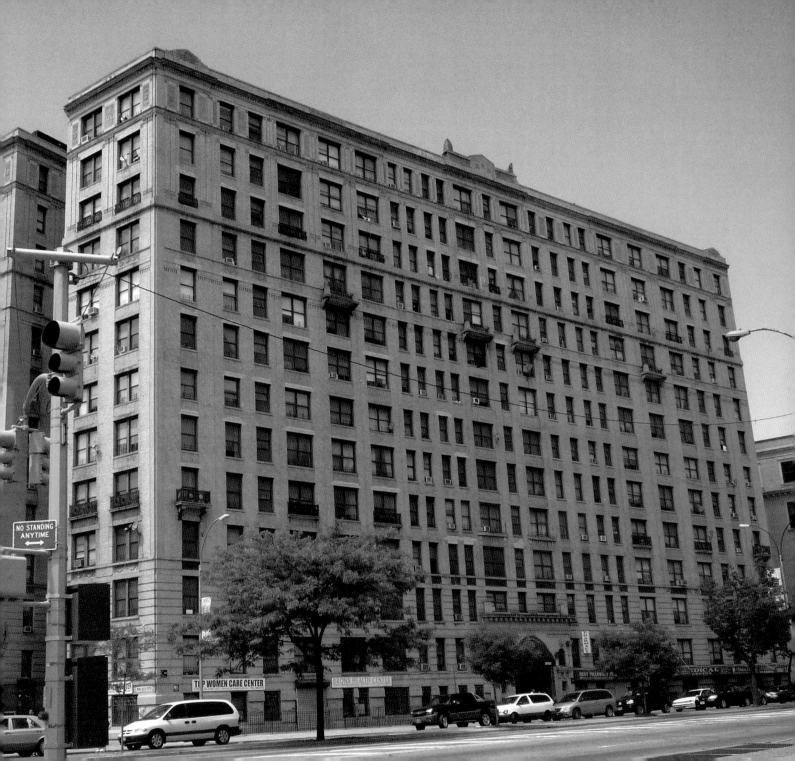

Today the complex appears rather banal, although at one time it was one of the most desirable addresses on the Grand Concourse. Even more desirable, however, was the apartment building called the Lewis Morris, at 1749 Grand Concourse at the northwest corner of Clifford Place. This large, classically detailed, and very stately building looks every inch the kind of prestigious building that upwardly mobile immigrants would aspire to occupy. It was designed by Edward Raldiris and built in 1923, and it is a far cry from those earliest "stage before art" apartment buildings on the Grand Concourse from the 1910s: the Lewis Morris looks as though it could be on Park Avenue in Manhattan.

Diagonally across the Grand Concourse from Roosevelt Gardens, at the southeast corner of 171st Street, is the Astor Concourse, built in 1924–25 by Vincent Astor of the famous real-estate family. This large building (nearly two hundred by two hundred feet) is of the Upper West Side luxury type with a vast internal courtyard. Astor's apartment buildings were often of striking architectural merit, and here he employed Aymar Embury II, an architect who had once worked for Cass Gilbert and later became a longtime associate of the city planner Robert Moses. Another interesting apartment building here is 1882 Grand Concourse, where the Concourse, 177th Street, and East Tremont Avenue converge to create an unusual triangular building site occupied by a flatiron-shaped twelve-story apartment building designed by Otto Schwarzler and built in 1914. It was the most richly appointed Concourse apartment building of its decade, and at one time the tallest building in the Bronx.

For many residents of the Bronx, the best-known building on the Grand Concourse is the Loew's Paradise, perhaps the most sumptuous movie palace ever built in New York, between 184th and 188th streets. It was built in 1929 and is among the rare buildings in the city to have received both exterior and interior landmark designations from the Landmarks Preservation Commission. The architect, John Eberson, is credited with inventing the "atmospheric theater"—a type of theater that included lobbies and auditoriums of astounding opulence, riots of columns and pilasters, arches and vaulted ceilings, fountains, chandeliers, statuary, cartouches, grand staircases, frescoed plaster surfaces, marble and gilt, and elaborate moldings. In addition, the auditorium of the Paradise features one of Eberson's patented ceilings, designed for the projection of changing sky scenes. The Paradise closed in 1994, seemingly another victim of the economic decline of this part of the Bronx, but in 2005, it reopened following a restoration undertaken by its new owner, Gerald Lieblich, who had also purchased and subsequently reopened the Russian Tea Room in Manhattan. The Paradise is now a major concert venue.

At the Grand Concourse and Fordham Road is the Dollar Savings Bank Building, which, with its high clock tower, is one of the most distinctive skyline buildings of the Bronx. Built in several phases (1932–33, 1937–38, and 1949–52), this building was also designated as both an exterior and interior landmark, in 1994. The architects,

Halsey, McCormack & Helmer, designed a number of outstanding buildings, including Brooklyn's tallest building, the Williamsburgh Savings Bank Tower (1927–29). The blocky stone mass along the Grand Concourse features stylized, trabeated classical forms reminiscent of those of the contemporaneous Bronx County Building at 161st Street. The clock tower, added in 1949–52, continues this treatment, although in brick rather than stone. The banking room inside is a dramatic art deco space with stylized classical details, reminiscent of such contemporaneous structures as Graham, Anderson, Probst & White's 30th Street Station (1933) in Philadelphia.

The Grand Concourse terminates at Mosholu Parkway, just to the south of Van Cortlandt Park. A block to the west, where West Mosholu Parkway South meets Jerome Avenue, stand Tracey Towers, two residential towers that rise to thirty-eight and forty-one stories and are now the tallest buildings in the Bronx. They were designed by the modernist master Paul Rudolph, with Jerald L. Karlan, and completed in 1972. The towers feature balcony bays framed by great, rounded turret-like forms that rise the height of the buildings. These "turrets" allow for semicircular rooms within the apartments—a rarity in New York City. The towers' façades of gray concrete blocks have a distinctive mottled, pliable, spongy appearance and testify to Rudolph's trademark concern with the expressive potentials of exposed concrete forms. The towers were built under the New York State Urban Development Corporation when its head, the famed urban planner Edward J. Logue, set out to employ top architects to design subsidized housing. Rudolph, perhaps the leading American figure in the phase of modernism called "brutalism," designed the controversial Yale Art and Architecture Building, completed in 1963, when he was the dean of Yale's School of Architecture.

If the Grand Concourse began at a "stage earlier than art," it soon enough became all art: not merely a place of physical righteousness, but an elaborate stage set for the drama of middle-class lives.

I wish to acknowledge my indebtedness to the "Grand Concourse Historic District" nomination form prepared in 1987 by the architectural historian Andrew S. Dolkart for the United States Department of the Interior's National Register of Historic Places. The Grand Concourse between 160th and 174th streets is a National Register historic district, but it lacks the protections and oversight that would come from being a historic district designated by the New York City Landmarks Preservation Commission. Although the city commission has designated a few Grand Concourse buildings (Public School 31, the Bronx Post Office, the Bronx County Building, the Andrew Freedman Home, the Loew's Paradise, and the Dollar Savings Bank) as individual landmarks, none of the Concourse's apartment buildings enjoys such protection. In fact, even the National Register district excluded such buildings as Philip Birnbaum's 1014 Grand Concourse, between 164th and 165th streets, built in 1963 and perhaps not yet considered sufficiently "historic" in 1987, although it is enormously important both as an exemplar of early 1960s style and as the last of the luxury apartment buildings to be built on the Grand Concourse.

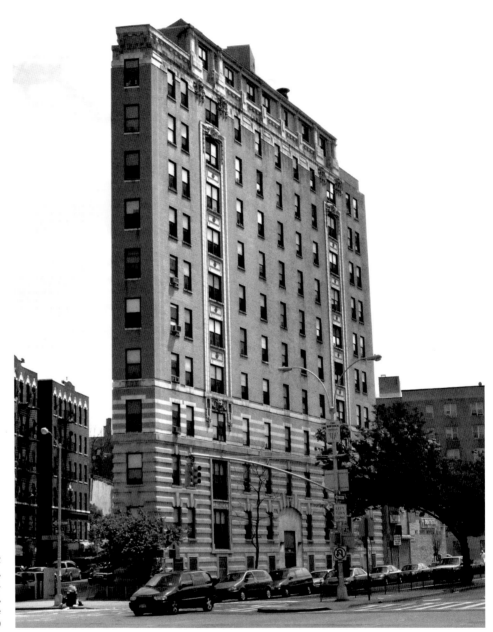

OTTO SCHWARZLER
1882 Grand Concourse,
the Bronx "flatiron" building, 1914
Intersection of Grand Concourse, 177th Street,
and East Tremont Avenue
Digital photograph by Edward A. Toran, 2009

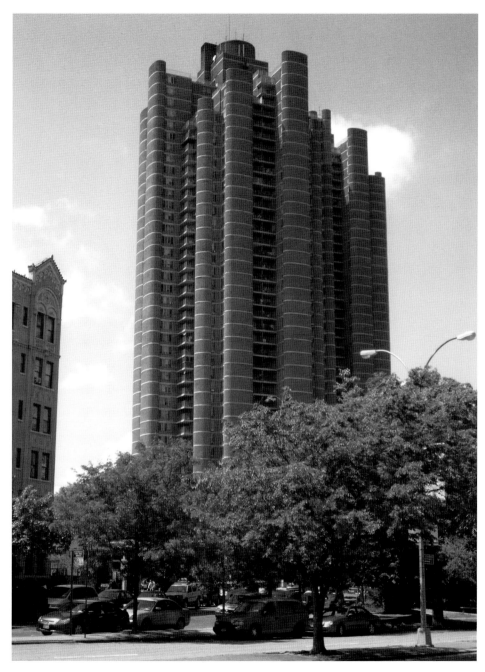

PAUL RUDOLPH AND JERALD L. KARLEN
Tracey Towers, 1972
West Mosholu Parkway South at Jerome Avenue
Digital photograph by Edward A. Toran, 2009

COMMISSIONS

JEFF CHIEN-HSING LIAO
KATIE HOLTEN
ACCONCI STUDIO
PABLO HELGUERA
KABIR CARTER
SKOWMON HASTANAN

JEFF CHIEN-HSING LIAO

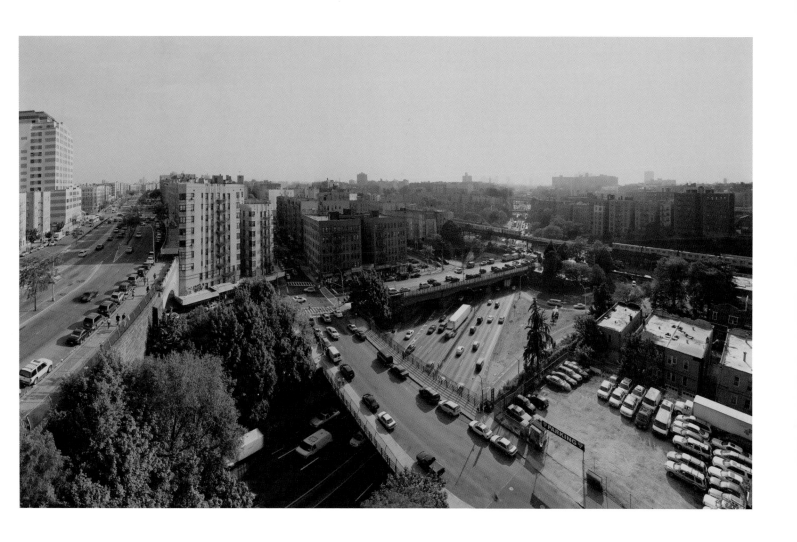

THE GRAND CONCOURSE
AND CROSS-BRONX EXPRESSWAY, 2008
Pigment ink print

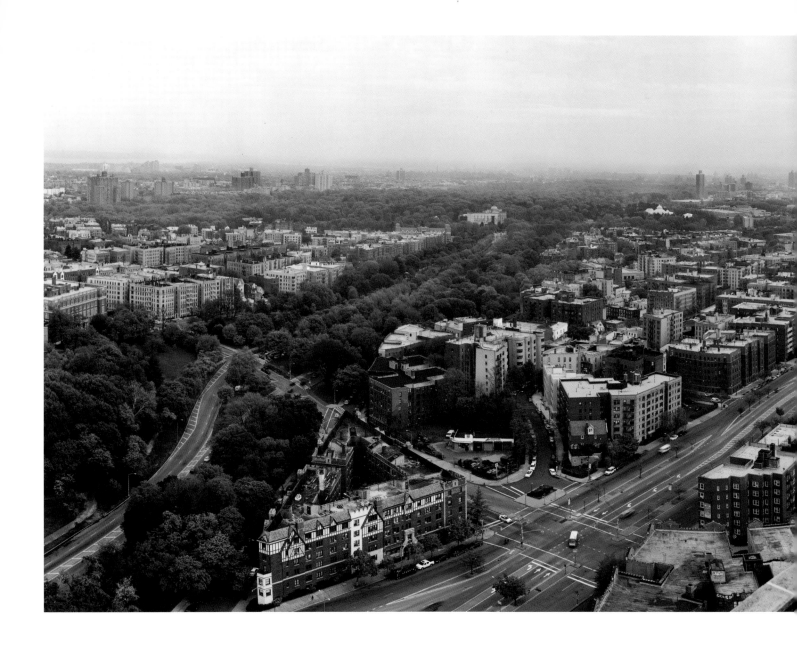

BIRD'S-EYE VIEW FROM TRACEY TOWERS, 2009
Pigment ink print

CONGO GORILLA FOREST, 2008
Pigment ink print

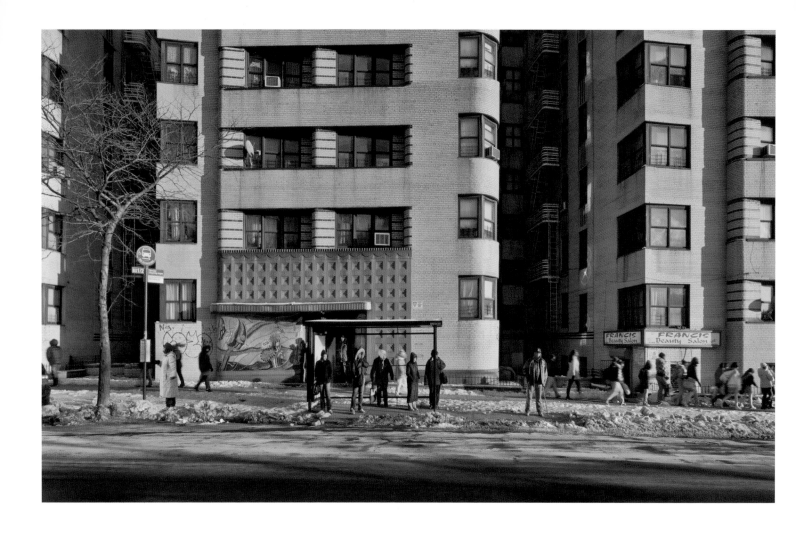

FISH BUILDING, 2009
Pigment ink print

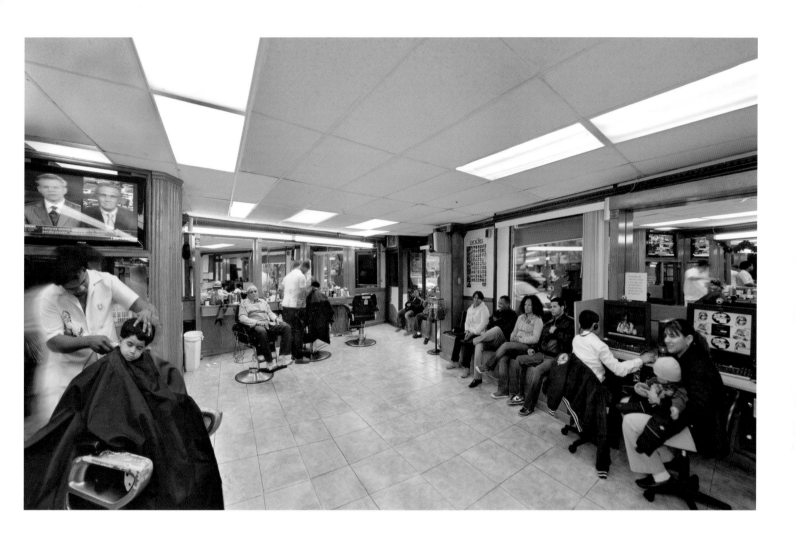

SURAIDY'S BARBERSHOP, 2009
Pigment ink print

YANKEE STADIUMS, 2008
Pigment ink print

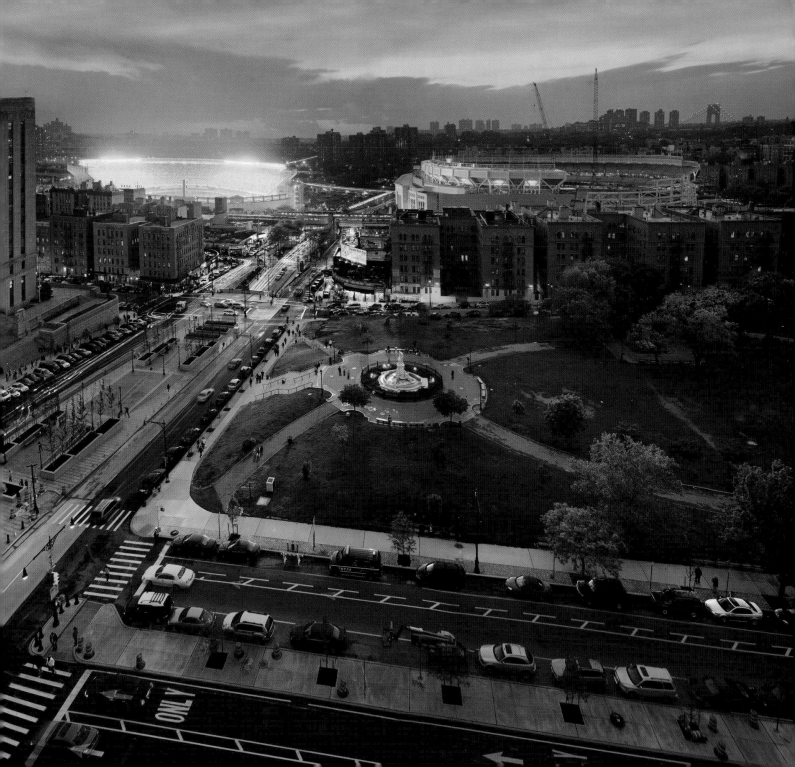

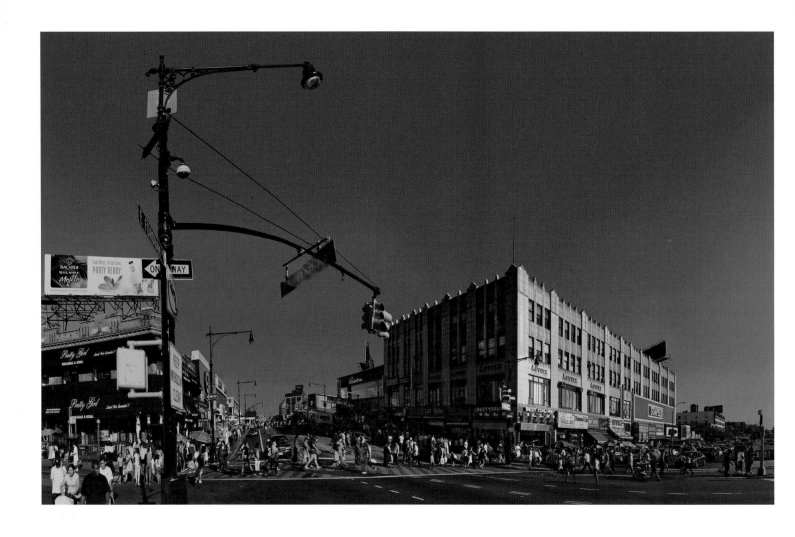

FORDHAM SQUARE, 2009
Pigment ink print

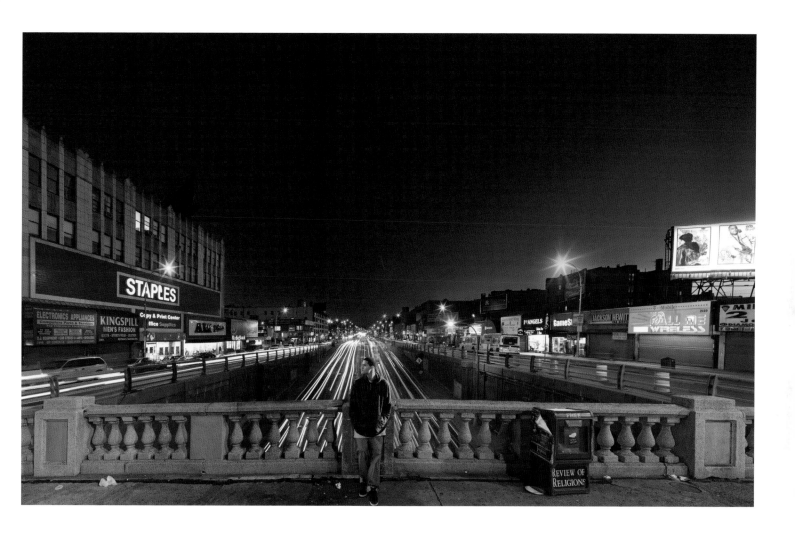

FORDHAM NIGHT, 2009
Pigment ink print

KATIE
HOLTEN

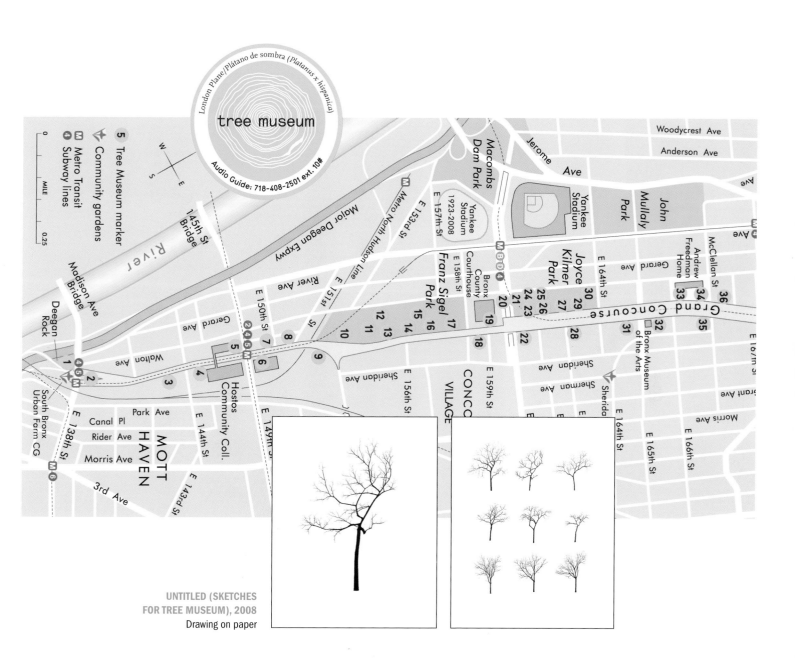

Map content (visible labels):

tree museum
London Plane/Plátano de sombra (Platanus x hispanica)
Audio Guide: 718-408-2501 ext. 10#

Legend:
5 Tree Museum marker
Community gardens
M Metro Transit
Subway lines

MILE 0 — 0.25

Compass: N W E S

Streets and landmarks.

London Plane/Plátano de sombra (*Platanus x hispanica*)

tree museum

Audio Guide: 718-408-2501 ext. 10#

5 Tree Museum marker
Community gardens
M Metro Transit
Subway lines

0 MILE 0.25

Woodycrest Ave
Anderson Ave
Jerome Ave
Macombs Dam Park
Yankee Stadium 1923-2008
Yankee Stadium
John Mullaly Park
McClellan St
Andrew Freedman Home
Gerard Ave
Grand Concourse
Joyce Kilmer Park
Bronx County Courthouse
Franz Sigel Park
E 153rd St
E 157th St
E 158th St
Major Deegan Expwy
Metro North Hudson Line
145th St Bridge
River
Madison Ave Bridge
Deegan Rock
Gerard Ave
River Ave
E 151st St
E 150th St
Walton Ave
Hostos Community Coll.
South Bronx Urban Farm CG
E 138th St
Canal Pl
Rider Ave
Morris Ave
Park Ave
E 144th St
E 143rd St
3rd Ave
MOTT HAVEN
CONCO VILLAGE
Sheridan Ave
E 156th St
E 159th St
Sherman Ave
Sheridan Ave
Sherida
Bronx Museum of the Arts
E 164th St
E 164th St
E 165th St
E 166th St
E 167th St
Grant Ave
Morris Ave

UNTITLED (SKETCHES FOR TREE MUSEUM), 2008
Drawing on paper

109

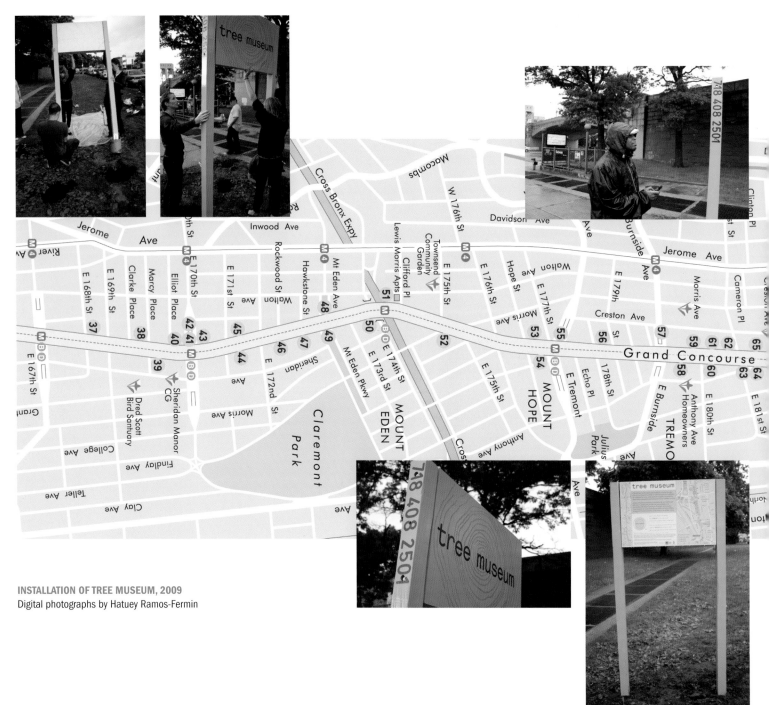

INSTALLATION OF TREE MUSEUM, 2009
Digital photographs by Hatuey Ramos-Fermin

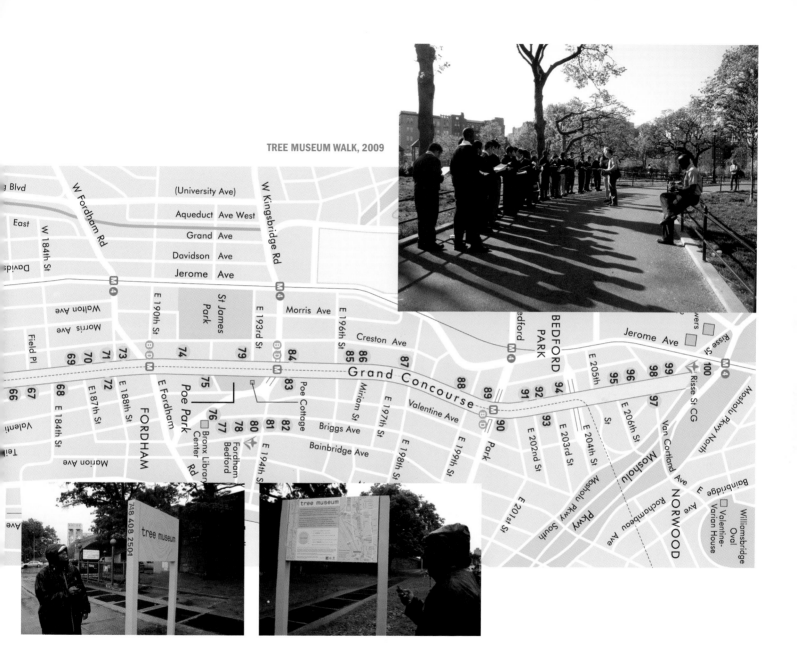

TREE MUSEUM WALK, 2009

111

Walking the Concourse almost every day, trying to get a feel for the street and understand how to engage with the place, at 174th Street, where the Concourse crosses over the Cross Bronx Expressway, I suddenly pictured the place as it might have been 100 years ago. So different: no buildings, no sidewalks, no asphalt, and no cars. But there were trees originally—it was built as a tree-lined boulevard for promenading. I saw the trees as a starting point for examining the entire ecosystem. Maybe it's because I grew up in the countryside, but I've always seen nature interconnected with the human-made: trees' roots grow down into the soil, which is surrounded by utilities and subway infrastructure. The trees' roots also push up and crack the sidewalks that people walk along. Rain falls into the cracks and is diverted into watersheds, which eventually reach kitchen and bathroom taps along the Concourse. Trees are alive; they grow and they have names, like people. They aren't just sticks coming out of the ground.

TREE MUSEUM WALK, 2009
Left to right: Katie Holten, Uli Lorimer,
E.J. McAdams, Joyce Hogi

The first concept sketches that Katie Holten designed for the Tree Museum convey an understanding of the physicality of the Concourse, the way it runs along a ridge offering significant vistas to the east and west, and the way people use it to connect from one place to another. In these early sketches, the correspondence between the street's traffic patterns and those of a leaf were clear and compelling, one living system serving as a model for another. Over the next eighteen months she delved into the pace of life and sought to understand how these patterns of exchange really work.

The concept of the museum as a model to present disparate information was another very appealing aspect of her design. As the project developed, museum methodology became a frame of reference to focus on the best way to convey the stories and experiences she was collecting. The museum itself could have taken many forms, but she quickly realized that the trees needed to be the focus. Once she latched onto the idea of an audio guide, it became an effective format for orchestrating the myriad stories into an effective presentation. The tree markers follow the protocol used to identify objects by museums and botanical gardens, as well as to key the visitor into the stories recounted on the audio guide.

In meeting countless people, Katie Holten took on a role more akin to that of a pollinator than to that of a museum director. In talking about nature and culture in the Bronx, asking questions and collecting stories, she has brought considerable attention to the critical role that trees play in the urban environment.

JENNIFER MCGREGOR
Senior Curator, Wave Hill

Art and architecture along the Grand Concourse have had three periods of expansion: the late nineteenth century, when the boulevard was laid; the 1930s, when art deco buildings were constructed and the Works Projects Administration commissioned public art; and today, as new development and investment restore the neighborhood to its original glory. The architecture along the Grand Concourse comprises a large collection ranging from art deco and art moderne structures to more contemporary styles including brutalism. Permanent art along the thoroughfare spans from nineteenth-century sculpture to contemporary interventions. Today, an increasing number of temporary art projects reflect current interest in the location as a place of many cultures and personal histories.

For her public art project on the Grand Concourse, instead of producing new material artworks, Katie Holten has used trees to explore all aspects of Bronx life—politics, architecture, ecosystems, and personal histories. She's on to something: New Yorkers live out their lives in the leafy greenness of tree-filled parks. Green spaces are a salve for the noise and harshness of the asphalt city.

Parks are where New Yorkers can be themselves, drop their all-business personae, and slow down. They become approachable. For centuries, artists have rendered green spaces, and parks are still drawn, painted, and used as gorgeous backdrops for sculpture and photography. But contemporary artists also choose park sites because they can reach and engage with participants for their interactive works.

CLARE WEISS
Curator, NYC Parks & Recreation

ACCONCI STUDIO

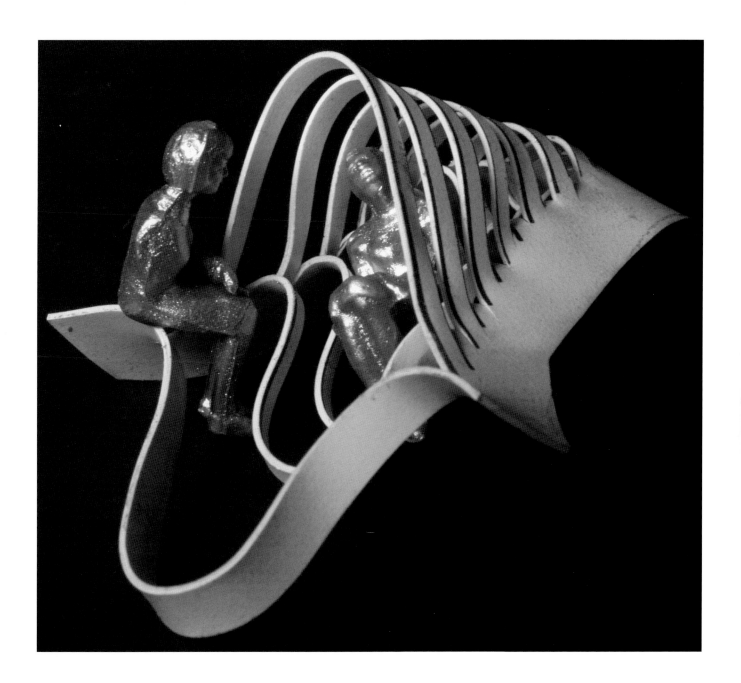

Let's try to get the best of both worlds: Corian® is not quite translucent, but it's not quite opaque either. Hard, slick Corian®: let's use it as if it's soft, as if it's fabric.

Cut it open & slit it into strips (it can be pulled now & stretched to one-&-a-half times its length): pit it & gouge it, pock-mark it (it's become malleable now, flexible): roll it & curve it, fold it, braid & knot it (it functions now as its own structure). Let's take slick, sleek Corian® & turn it into lace: let's take the surface of lace & mold it into structure.

Corian® knows what it is & so do we: it's used as counter-tops & table-tops—that's why it's 12 feet long but only 30 inches wide. But all we have to do is notch panels together, & we can have sheets 7 feet wide, 10 feet wide: this isn't only furniture, it's architecture.

Once we notch panels together, we have walls & floors & ceilings. Let's renovate the Bronx Museum lobby, if only for the time being. Start in the middle of things; start with the columns in the middle of the lobby: curve the end of a horizontal wall around one column—now draw the wall out, wind it around, spiral it around the other column. Look down now: lay an undulating floor down, between the columns & the entrance. Look out now, look out the front window; let's put up another wall, this one a vertical wall: hang it like a screen in front of the window-alcove—we've enclosed the alcove, we've made a little room with a view, a view to the outside. But we won't go outside, we'll go farther in, inside the lobby: we're at the ramps at the back of the lobby: let's raise a wavy ceiling above the first ramp up.

Now that we have a new architecture in the lobby, the furniture of the lobby can emerge from it. Once a slit is made in the wall, the Corian® can be bent down to function as a shelf; once a slit is made in the floor, the Corian® can be raised up to be a seat—make another slit & the Corian® be raised farther up as a table; once a slit is made in the curtain-wall in front of the window-alcove, then light from outside slips into the lobby; once a slit is made in the ceiling above the ramp, something has to pass through, down upon people walking up the ramp.

What passes through, deep inside the lobby, is projection-light: it's the people passing through the lobby that activate sensors that, in turn, activate projections. As you walk through, you cast a shadow: not a dark shadow but a multi-colored, shifting-colored shadow, & not on the floor below you but on a ceiling above you or on a wall at the other side of the room—you throw your shadow as if throwing your voice. On top of the thick skin of Corian® comes a second skin, a third skin, etc.

MODEL FOR LOBBY INSTALLATION

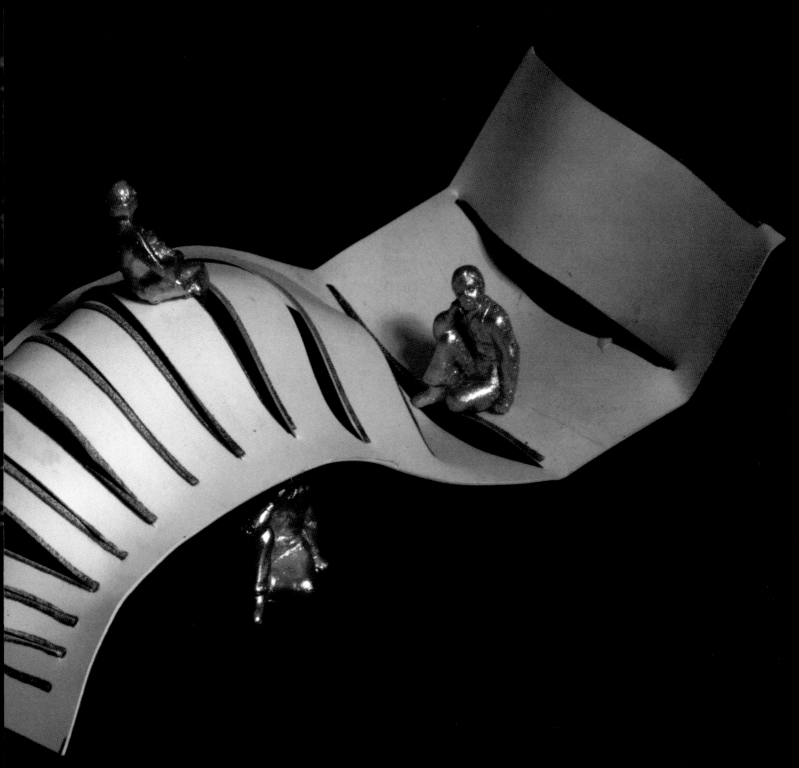

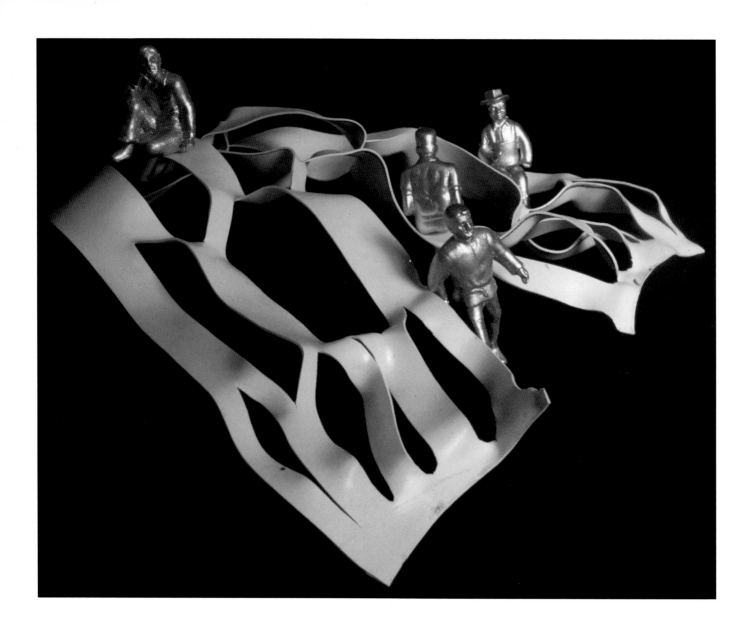

MODEL FOR LOBBY INSTALLATION

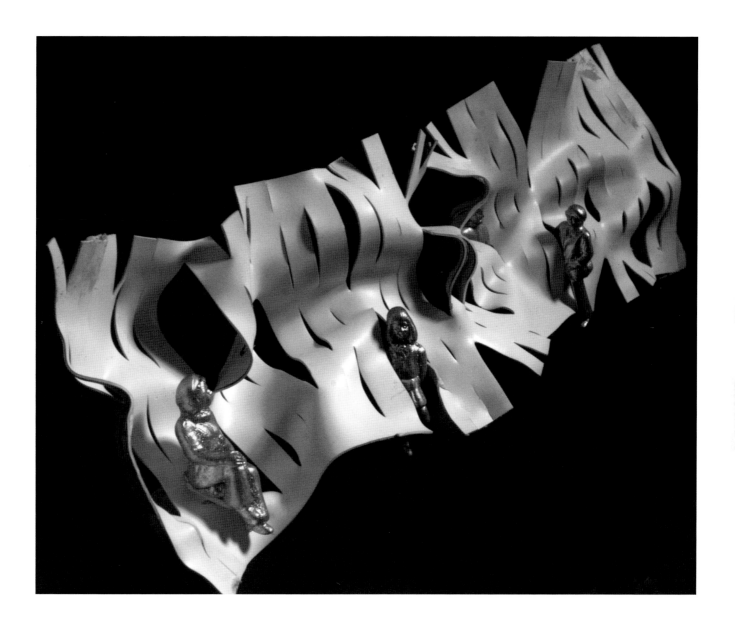

PABLO HELGUERA

The entertaining rooms are as grand as many private clubs of the period, and the guest rooms upstairs compare favorably with the scale and finishes of Park Avenue apartment houses.

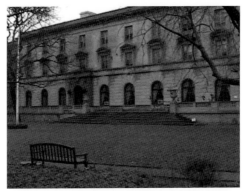

It is the grandest residence in the Bronx, resembling a European mansion in the Italian Renaissance Style.

Couples are to be kept together in their twilight years and provisions were to be made for the survivor. This idea of not separating couples is a dominant note in his will and was unheard of then and now.

STILLS FROM PARADISE, 2005-2009
Three-channel video installation, 8:30 min.
Black and white, silent

Three buildings on the Grand Concourse are inextricably connected to Bronx history: the Lowe's Paradise theater, designed by the renowned architect John Eberson, a main proponent of "atmospheric" movie theaters, which opened to the public in 1929 a few weeks before the stock market crash that led to the Great Depression; the Andrew Freedman Home, a luxurious retirement place for bankrupt millionaires built by an eccentric New York transportation mogul who believed that those who had once experienced wealth would need greater comfort than others who had always lived in poverty; a small nineteenth-century cottage where Edgar Allan Poe spent the last years of his life and wrote some of his bestknown works, such as "Eureka," "Annabel Lee," and "The Bells." The concept of "Paradise" is invoked in the three-channel video installation through still images from the three buildings and additional text, unfolding a non-linear narrative in the present tense.

STILLS FROM PARADISE, 2005-2009
Three-channel video installation, 8:30 min.
Black and white, silent

It is a time pregnant with too much unrealized potential, where the present moves uneasily into the future.

And Oh, the tranquil hours we'll spend, Never wishing that others may see!

The farmhouse stood on the east side of the road separated by the thoroughfare by lilac bushes and cherry trees.

STILLS FROM PARADISE, 2005-2009
Three-channel video installation, 8:30 min.
Black and white, silent

KABIR
CARTER

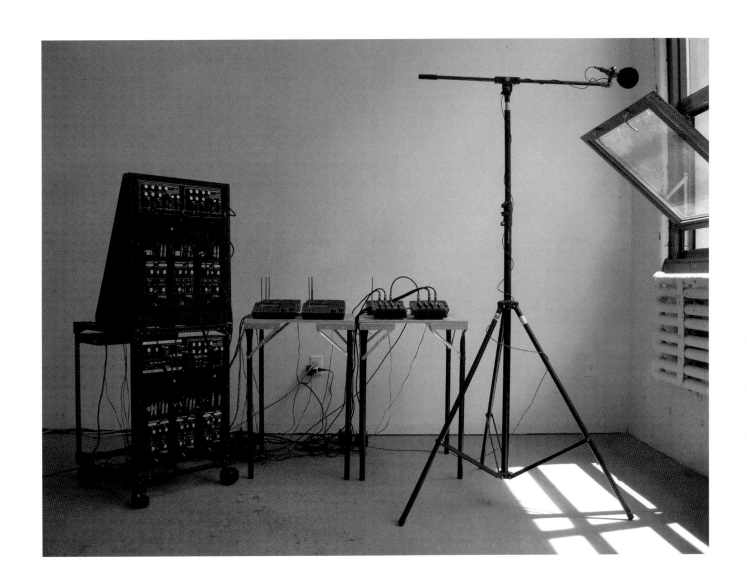

UNTITLED, 2009
Digital photograph

Multidirectional movements of street traffic produce varied sounds and acoustic effects along a street and its intersections. Acoustic artifacts emanating from these sounds are discerned as performance energy. These energies, drifting along the edges of the building, are collected at multiple points by transducers extending from architecture. Locally transmitted, radiophonically borne activities are concurrently drawn in and mixed with traffic-driven airborne sounds. All of these are further combined and mixed with and employed to drive electronic modifiers. Varied resultant mixtures are projected into crevices and spaces between architecture and street, and inside and outside, to establish and construct the form of a supplemental space.

UNTITLED, 2009
Digital photograph

UNTITLED, 2009
Digital photograph

SKOWMON
HASTANAN

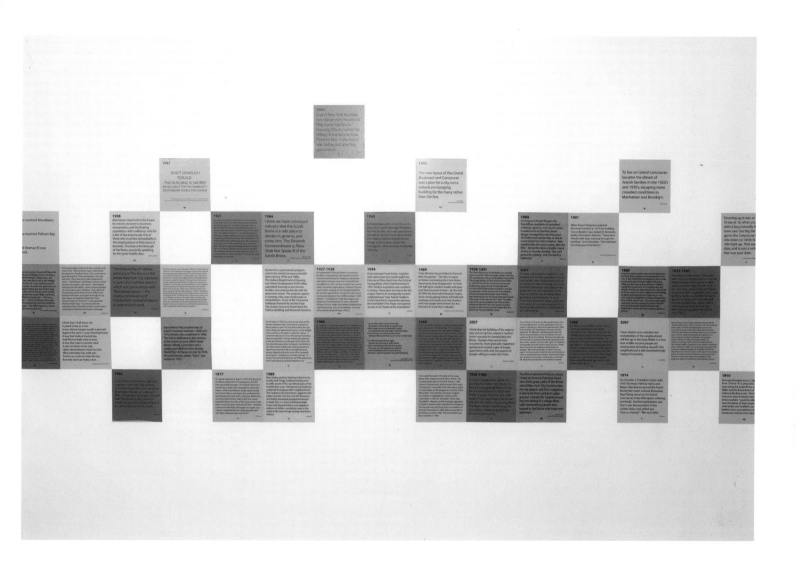

GRAND CONCOURSE TIMELINE (DETAIL), 2009
Vinyl panels
Digital photograph by Bill Orcutt

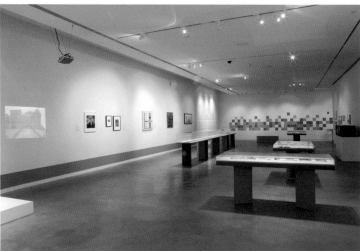

History is collective memory, the sum of individual experiences. The Grand Concourse Timeline features several narratives procured from books, articles, and poems, as well as interviews presented in square grids installed randomly, in a nonchronological order. The narratives trace the Bronx's rapid process of urbanization after the construction of the Concourse and comprise selected excerpts from personal, historical, and contemporary documents, including news articles, government papers, business advertisements, music lyrics, literary works, and interviews. They convey a continuous narrative and reveal the social, economical, and geographical changes of the Bronx landscapes—from an open space to a crowded place, from an optimistic and rich beginning through the devastation, and back to the revitalization. The history of the Bronx is one of constant influx, and its narrative is constantly in the making, words and testimonies contributed by the people who came and moved away, or stayed to live, invested in, and love this place.

GRAND CONCOURSE TIMELINE, 2009
Vinyl panels
Digital photographs by Bill Orcutt

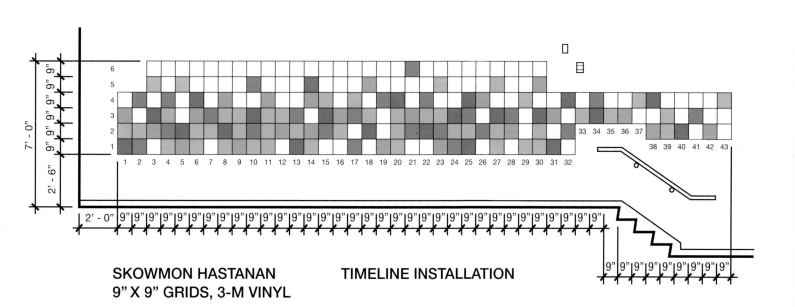

112 PANELS

23 panels
23 panels
22 panels
22 panels
22 panels

LARGE FONT / SHORT TEXT TOP

SMALL FONT / BUSY TEXT BOTTOM

SKOWMON HASTANAN
9" X 9" GRIDS, 3-M VINYL

TIMELINE INSTALLATION

THE GRAND CONCOURSE
BEYOND 100

DEBORAH MARTON

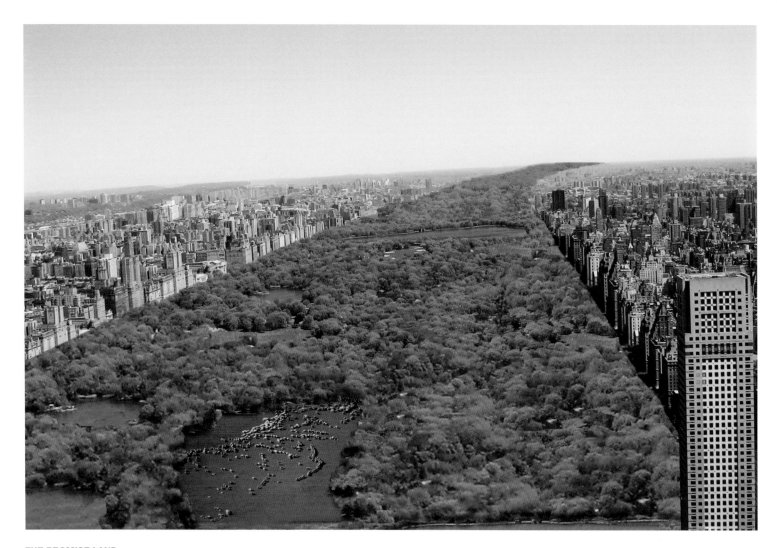

THE PROMISE LAND
The axis of Central Park is extended from
Manhattan further up northward into the Bronx,
providing connective green streetscapes between
key city parks and promoting urban agriculture.
© Jorgaqi + Choi Design Partners
Courtesy of The Design Trust for Public Space

P ublic streets have always been the bellwether of a healthy society. Well-designed streets allow residents to be themselves—individual human beings with unique world visions—while also communicating the message that every individual is an important member of the larger community. The best public spaces foster a sense of civic optimism critical to building the social cohesion necessary for a high quality of life and economic prosperity. They also encourage every individual to become more active participants in his or her own life, by providing opportunities for a range of social interactions—from sports to green markets to public exhibitions to playgrounds to urban agriculture—with enough flexibility for users to feel a sense of empowerment.

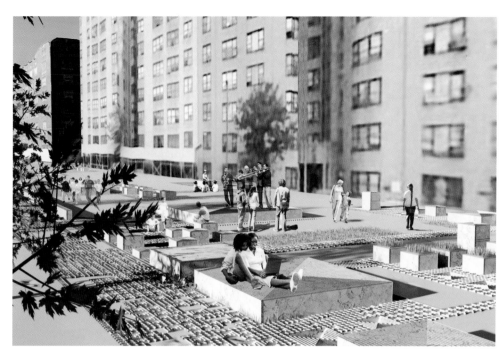

With these important benefits in mind, in early 2009 The Bronx Museum of the Arts and the Design Trust for Public Space launched an ideas competition as part of the museum's year-long celebration of the Grand Concourse's centennial. The competition, entitled *Intersections: The Grand Concourse Beyond 100*, was created to generate bold new visions for the Bronx's storied thoroughfare. By the time the competition closed, almost 400 people from more than 25 countries had submitted proposals. The proposals came from leading and emerging architects and designers, artists, city planners who have spent decades working in the Bronx and visionaries from all over the world, including Australia, Korea, Japan, Europe, South Africa, and Mexico.

The purpose of the competition was to elicit quickly the broadest possible spectrum of concepts for improving the Grand Concourse. Not surprisingly, the overwhelmingly dominant theme was recapturing the Concourse for pedestrians. The vast majority of schemes submitted de-emphasize the automobile in favor of flexible, greener spaces that identify the Concourse as a destination in itself, and an integral part of the surrounding communities.

Many entrants borrowed ideas from the world's great boulevards, such as the Paseo de Gracia in Barcelona, the Boulevard Saint-Michel in Paris, and the Cours Mirabeau in Aix-en-Provence. These magnificent streets speak both to the grandeur of their globally important cities but also of the ordinary daily life of the cities' inhabitants. Those bou-

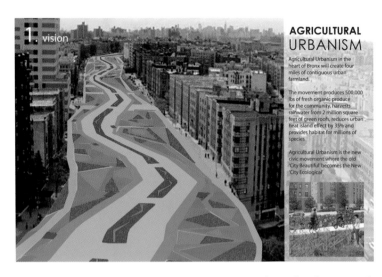

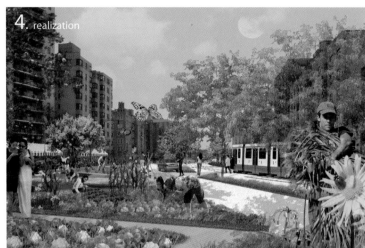

1. vision

AGRICULTURAL URBANISM

Agricultural Urbanism in the heart of Bronx will create four miles of contiguous urban farmland.

The movement produces 500,000 lbs of fresh organic produce for the community, harvests rainwater from 2 million square feet of green roofs, reduces urban heat island effect by 35% and provides habitat for millions of species.

Agricultural Urbanism is the new civic movement where the old 'City Beautiful' becomes the New 'City Ecological'

4. realization

AGRICULTURAL URBANISM
Layers of agriculture, transit, and dynamic public space, brings health and vitality to neighborhoods through localized food production.
© EDAW/AECOM
Courtesy of The Design Trust for Public Space

levards share particular physical characteristics. Often sited in cities to give structure to the city as a whole, all great boulevards also richly serve local residents. Local and through traffic are segregated, with appropriate speeds and safe, well-identified crossings for pedestrians. Spaces for recreation include places to sit and well-conceived, mature plantings. Surfaces, street furniture, and other details are meticulously maintained and made of the highest-quality materials. Some boulevards, like Barcelona's Ramblas, encompass public markets and other active uses. But even in the absence of this sort of programming, the world's great boulevards all create a stage for the life of the city to unfold.

The classic response to our call for new visions for the Concourse would have been to recommend narrowing the traffic lanes on the Concourse's two side access roads and using the space gained to widen the medians. This strategy would increase pedestrian safety and provide new, occupiable green space. Indeed, many submissions made such recommendations and also restored the original plantings and spaces for nonmotorized uses that have been lost over the past century. Others observed that the current width of traffic lanes encourages high-speed traffic flow not suited to a boulevard such as the Grand Concourse.

A random selection of images from among the many entries illustrates the themes that emerged from the nearly 200 submissions. The vast majority of proposals asserted that the Grand Concourse should be transformed from a high-speed vehicle thoroughfare into a dynamic new pedestrian-oriented public space. There was enormous variability in the way submissions imagined this new space, but a few themes dominated. At the top of this list was the Concourse's greening—literally, by increasing plantings and green space, and conceptually, by using the Concourse to support new green

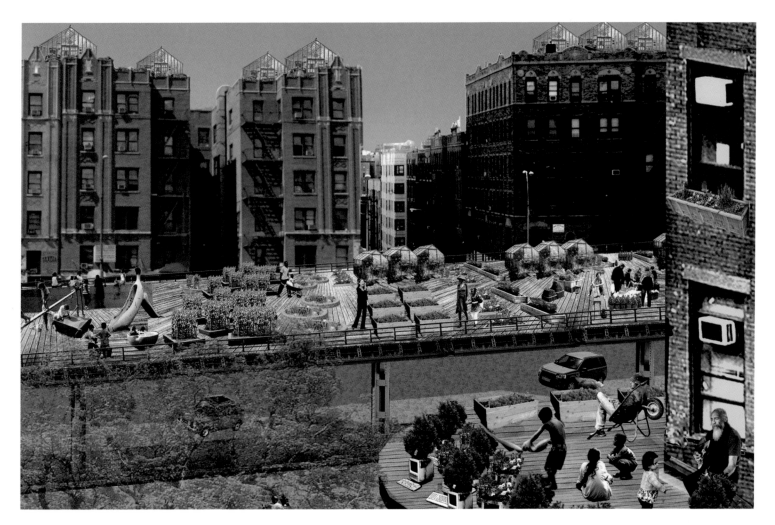

THE EDIBLE CONCOURSE
A raised platform straddling the middle of
the concourse minimizes food deserts and
promote urban agriculture.
© Brendan Cormier
Courtesy of The Design Trust for Public Space

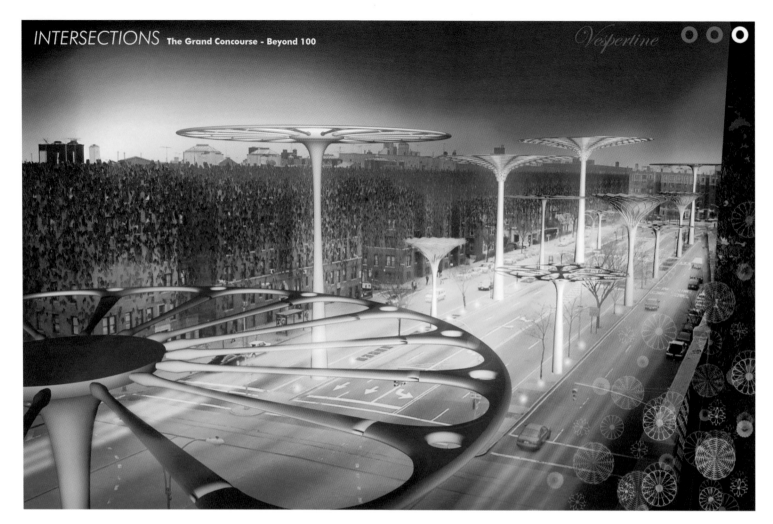

VESPERTINE
High-tech flowers provide solar energy, water
recycling, street shade and heat distribution.
© Gabriel Belli Architect
Courtesy of The Design Trust for Public Space

infrastructure like stormwater collection systems and permeable pavement. One low-tech exploration of this theme would turn the Concourse into a four-mile farm with grazing cows. Many submissions focused on better integration of public transportation modes, including separate strands for pedestrians, bicycles, cars, and light rail. Flexibility is a repeating theme, with entrants developing spaces that could be physically reconfigured for a range of activities, including communication; one scheme includes interactive walls that would allow pedestrians on the Grand Concourse to communicate with people in other cities around the world. To express the borough's cultural vitality at the street level, the Concourse's identity was explored through material and street furniture choices, new programming, and landmarks that draw on the borough's musical and artistic vibrancy.

Perhaps in reaction to the deadly combination of rent control laws and misguided public housing policies that plagued the Bronx in the 1960s and 1970s, most submissions avoid top-down, large-scale infrastructural solutions and instead favor development of site-specific, informal, adaptable spaces. A few submissions create new space by looking upward, whether by creating discrete raised platforms or by greening roofs atop existing apartment buildings along what one entrant called the "art deco cliffs." Others look below grade, placing new plazas and civic buildings in subterranean spaces or, more simply, laying a glass ceiling atop an existing subway station. Still others see opportunities in living green walls, outdoor cafés, and the re-purposing of the spaces between apartment buildings into shared mixed-use "alleys."

The current state of economic hardship across the city and around the world creates challenges but also opportunities for reimagining the future of the Bronx. While many other parts of New York City experienced unprecedented growth and overdevelopment in the past decade, expansion and its culturally destructive partner, gentrification, occurred in the Bronx at a steady, much more modest pace. This leaves the borough in a solid position now that the development boom has ended. Instead of confronting the myriad complex problems resulting from overdevelopment, residents of the Bronx find themselves to be in relatively the same position they have been in since the 1980s. Over the next several decades, as the economy recovers, the Bronx has a strong foothold on how best to approach growth and development, and happily it still retains its fine housing stock and elegant art deco architecture largely intact.

The enthusiastic global response to this call for ideas proves that now is the time to make sure that the Bronx's omnipresent dynamism, occasional radicalism, and enduring creativity find expression in the public realm. In the next 100 years, the Grand Concourse is perfectly situated to demonstrate how well-designed public spaces, respect for pluralism and diversity, variations in scale, density, layered activities, and distinctive design can breathe new life into cities across America.

BRONX CONNEXION
A mixed-use tower spanning the river in the shape of an X gives identity to the Grand Concourse and the Bronx.
© D+DS architecture office
Courtesy of The Design Trust for Public Space

CHRONOLOGY

Birth register of Jean-Alloeus Risse, 1850
Courtesy Pascal Flaus and Sébastien Vion

1835

The Culprit Fay and Other Poems by Joseph Rodman Drake, which contains an ode to the Bronx, is published posthumously. Drake (1795–1820), a trained physician and pharmacist, wrote both romantic and satirical poetry; his work contributed to the beginnings of a national literature in the United States.

1846

Edgar Allan Poe (1809–1849) rents a cottage in the Fordham section of the Bronx for $100 a year and moves in with his young wife, Virginia, and his mother-in-law. Poe had hoped that the fresh air and bucolic landscape of the Bronx would have a palliative impact on his ailing wife, but she died of tuberculosis the following year. During the brief period when he lived in the Bronx, Poe spent his time gardening, exploring nature, and engaging in intellectual discussions with the Jesuits at nearby St. John's College, now Fordham University. Notable writings during his stay at the cottage include "The Bells," "Eureka," and "Annabel Lee." Poe remained in the cottage until his own death, which occurred during a trip to Baltimore in 1849. The cottage's original structure is believed to have been built around 1797. In 1913, it was moved about 450 feet from its original location on Kingsbridge Road and Valentine Avenue to its current location at the Grand Concourse.

1850

On March 28, Jean-Alloeus Risse is born in the city of Saint Avold, in French Alsace. At the age of seventeen, he immigrated to New York and later became known as Louis Aloys Risse, "father of the Grand Concourse."

1870

The New York State Legislature gives the New York City Parks Department jurisdiction over the streets of what is now the west Bronx (west of the Bronx River).

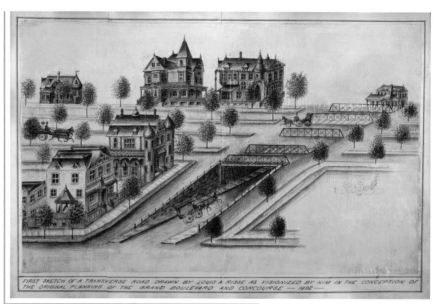

LOUIS A. RISSE

First Sketch of a Transverse Road, 1892
Watercolor and ink on paper
The Museum of the City of New York

1874

The area west of the Bronx River in what later became the Bronx—until this time a part of Westchester County—is annexed by New York City, which had previously consisted solely of the island of Manhattan. The area is called the Annexed District or the Great North Side.

1884

The New Parks Act is passed by State Legislature, authorizing the acquisition of land for St. Mary's, Claremont, Van Cortlandt, Pelham Bay, Bronx and Crotona Parks, and for the Mosholu and Pelham Parkways.

1890

The Department of Street Improvements of the 23rd and 24th Wards is created by the State Legislature, and Louis J. Heintz is appointed Commissioner. The Department of Street Improvements takes over responsibility for streets from the NYC Parks Department.

1892

Louis J. Heintz, the Commissioner of Street Improvements in the 23rd and 24th wards, proposes to the city government the construction of a new "speedway" in the Bronx. The proposal had been conceived by Louis Risse, who was Heintz's chief engineer and was later responsible for laying out the Grand Concourse. Regarding this proposal, Mayor Hugh J. Grant told the *New York Times* that "It should not be built for a time, but for all time. The plan and design of such a boulevard should be such that it will be free for all time from the encroachment and demands of traffic and business, and that, while it will be a lasting source of enjoyment and health for the present and future generations, it will in no way impede the progress of our city's growth in trade, traffic, and commerce, but on the contrary strengthen and accelerate it."

HENRY E. RILE

Part of Old Mill on the Bronx near Boston Ave. Bridge,
October 27, 1893
Graphite, black ink, and black wash on paper
New-York Historical Society
Gift of Daniel E. Rile

1893

Louis J. Heintz dies at the age of thirty-two. Louis F. Haffen, the next Commissioner of Street Improvements, takes over the planning of the thoroughfare, assisted by Louis Risse. Haffen later becomes the first Bronx Borough President.

For a period of over 20 years starting in 1893, Henry E. Rile creates numerous drawings and sketches depicting farmland and rural life in the Bronx. As a young man, Rile (1840–1922) worked for the construction industry in Wisconsin, and in 1862 he returned to New York, where he became known for his renderings of buildings and copies of historical prints. The Bronx sketches were compiled by the artist as an album; they depict natural surroundings in the borough, including parkland, gardens, and several farm buildings.

1895

The area east of the Bronx River is annexed by New York City, joining Manhattan and the area west of the Bronx River.

A bill is passed by the City Council approving the plan of the Grand Concourse. Given its popular support, the bill was signed by the Mayor and approved by the Governor within two weeks.

1897

Risse publishes *History in brief, of the conception and establishment of the Grand Boulevard and Concourse in the 23d and 24th wards* (New York: The Bell Press).

1898

On January 1, the City of Greater New York, including all five boroughs, is created following the incorporation into the city of Richmond County, Kings County, the western part of Queens County, and the area east of the Bronx River.

The Bronx becomes a Borough, with Louis F. Haffen as Borough President.

1899

The Lorelei Fountain is unveiled in the Bronx after a bitter controversy and a long series of negotiations. Created by Ernst Herter (1846–1917) in 1893 as an homage to the poet Heinrich Heine, the work was commissioned by Princess Elizabeth of Austria as a gift to the city of Düsseldorf, Heine's birthplace. Rejected by the citizens of Düsseldorf, the monument was purchased by a group of Americans of German descent and offered to New York City. Following six years of debate, the Lorelei Fountain finally found a permanent home in the Bronx; it is currently at the southern end of Joyce Kilmer Park.

1900

Risse produces a "General map of the city of New York, consisting of boroughs of Manhattan, Brooklyn, Bronx, Queens and Richmond: consolidated into one municipality by act of the legislature of the state of New York (Chapter 378 of the laws of 1897): showing in addition to the existing topographical and characteristic features of the city, a tentative and preliminary plan for a system of streets in those parts of the city consolidated under the above act of the legislature and which had no official street plan prior to 1898 / designed and prepared by Louis A. Risse." The map includes views of city landmarks within a decorative border, along with borough area and population statistics. The original map was exhibited at the Paris Exposition of 1900 and was awarded the grand prize by the International Jury of Class 29—Group VI (models, plans, and public works).

1902

Construction of the Grand Concourse begins. The Christmas 1903 issue of *The North Side News* describes the future boulevard as follows: "The grand avenue will in the nature of things be a pleasure thoroughfare from which anything that smacks of commerce, trade or business, will be excluded as far as possible."

Risse publishes *The True History of the Conception and Planning of the Grand Boulevard and Concourse in the Bronx* (publisher unknown).

Poe Park opens, on the Grand Concourse between 192nd Street and Kingsbridge Road.

1905

What is now known as the number 2 line becomes the first subway to enter the Bronx.

Louis F. Haffen
Ink on paper
The Bronx County Historical Society Collections

1909

Louis F. Haffen's Borough Presidency ends on August 30th as a result of accusations of misconduct made by Governor Charles Evans Hughes and Mayor George B. McLennan. Haffen is replaced as Borough President by John F. Murray, who oversees the ceremonies celebrating the opening of the Grand Concourse, running north from 161st Street to Mosholu Parkway.

c. 1910

The San Francisco–born painter Ernest Lawson (1873–1939) spends time in the Bronx, where he paints several works inspired by the local landscape, including settings along the Bronx and Harlem rivers and Spuyten Duyvil Hill.

1914

The Bronx becomes a county.

1918

The Jerome Avenue IRT line (now known as the number 4 line), which extends north to Woodlawn Road, opens in the Bronx, sparking residential growth along the Grand Concourse.

c. 1920

A great number of six-story buildings are constructed along the Grand Concourse throughout the decade. Numerous Jewish families move to the area, and the Grand Concourse becomes known as the "Park Avenue" of the Bronx.

1922

Roosevelt Gardens is built on 171st Street and the Grand Concourse.

1923

The luxurious Concourse Plaza Hotel opens its doors at the Grand Concourse and 161st Street.

Yankee Stadium opens in the Bronx at 161st Street and River Avenue. During the opening game, Babe Ruth hits the stadium's first home run.

1924

The Andrew Freedman Home opens at 167th Street and the Grand Concourse.

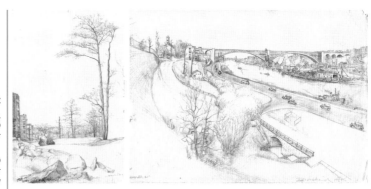

IRA MOSKOWITZ

*Trees and Rocks in Crotona Park,
Bronx*, 1929
Pencil on paper

Harlem River, 1929
Pencil on paper
Courtesy of the artist's family

1925

Louis Risse, "Father of the Concourse," dies at his home on 599 Mott Avenue—an address that shortly ceased to exist, as the Grand Concourse extended southward.

1927

Mott Avenue is widened and annexed by the Grand Concourse to extend the boulevard from its original starting point at 161st Street to the Mott Haven section of the Bronx, at 138th Street.

Adolph Gottlieb's *Grand Concourse* is painted. A small oil-on-canvas figurative composition, this work is entirely different from the abstract expressionist style for which Gottlieb (1903-1974)—a founding member of the New York School—later became known.

1929

The Loew's Paradise Theatre opens on the Grand Concourse.

The artist Ira Moskowitz (1912–2001) creates a series of drawings in the Bronx, including views from High Bridge and Crotona Park, that documents the Bronx's changing landscape in both urban and rural scenes.

1930s

During these years, especially after the worst of the Great Depression ended, construction along the Grand Concourse intensified, including the erection of dozens of art deco apartment houses, which constitute one of the largest collections of art deco buildings in the United States.

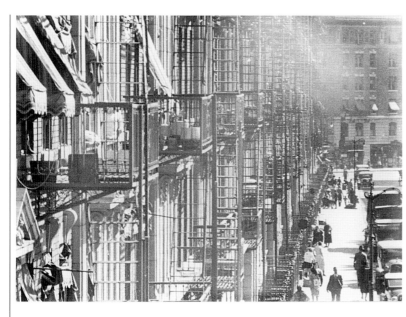

JAY LEYDA

A Bronx Morning, 1931
DVD transfer from 16mm, black and white,
silent, approximately 11:00 minutes
The Museum of Modern Art,
Circulating Film Library, New York

1932 **1933** **1934** **1935**

The filmmaker Jay Leyda produces *A Bronx Morning*, an 11-minute black-and-white documentary about the Bronx. Leyda (1910–1988) was a leading film historian, known for his work on Soviet and Chinese cinema. He was also a photographer, archivist, translator, and professor of cinema studies at New York University, as well as being noted for his Emily Dickinson and Herman Melville scholarship. *A Bronx Morning* was Leyda's first film, and it led to his being accepted at the Moscow State Film School, where he studied film directing with Sergei Eisenstein.

During his presidential campaign, Franklin D. Roosevelt comes to the Bronx and speaks at the Concourse Plaza Hotel.

The Concourse subway opens, sparking further residential development; the D and B trains now run on this line.

The Bronx County Courthouse at 161st Street and the Grand Concourse is completed.

The Alexander's department store opens at Fordham Road and the Grand Concourse.

For a period of seven years, the artist Burgoyne Diller (1906–1965) holds several appointments in the Works Progress Administration (WPA) / Federal Art Project, including director of the New York City mural division and liaison to the New York World's Fair Committee. In these positions, he is able to assign projects and commissions to other contemporary artists. Born in the Bronx, Diller had studied at the Art Students League under Hans Hofmann; in the early 1930s, he became influenced by movements like Russian constructivism and De Stijl.

1936

The cornerstone is laid for the Bronx Central Post Office at 149th Street and the Grand Concourse.

Joyce Kilmer Park is completed. The park is dedicated to Alfred Joyce Kilmer (1886–1918), an American poet killed in action in World War I.

Construction of the "fish building" begins at the northeast corner of McClellan Street. Designed by Horace Ginsbern, the building's sweeping, curved entrance features a large, two-part, vibrantly colored mosaic mural of marine life.

1937

The photographer André Kertész (1894–1985) arrives in New York for a short visit. With the outbreak of the war in Europe, he decides to stay, finding work as a freelance photographer for magazines such as *Harper's Bazaar, Vogue,* and *Look.* In his free time, Kertész photographs the streets around New York City, including those in the Bronx.

1938

The artists Ben Shahn and his wife, Bernarda Bryson, win a commission from the WPA and the U.S. Treasury Department for the mural *America at Work,* for the Bronx post office. Shahn (1898–1969) had met Bryson (1903–2004) in 1933, while working as assistant to the Mexican muralist Diego Rivera.

1942

Lebanon Hospital opens at Mt. Eden Avenue and the Grand Concourse.

PHILIP BIRNBAUM
Executive Towers apartments
1014 Grand Concourse, 1963
Digital photograph by Edward A. Toran, 2009

1945

Robert Moses (1888–1981) proposes a six-lane expressway to run through the Bronx. Its actual construction posed a series of challenges, as it required blasting through ridges, crossing valleys, and redirecting rivers. The expressway (which would become the Cross Bronx Expressway) was to cross 113 streets, seven expressways and parkways, one subway line, five elevated lines, three commuter rail lines, and hundreds of utility, water, and sewer lines.

1955

The first section of the Cross Bronx Expressway opens, from the Bronx River Parkway to the Bruckner Interchange.

1960

The Executive Towers opens at 165th Street and the Grand Concourse.

The congregation of Young Israel of the Concourse erects a synagogue at the northeast corner of the same intersection.

1963

The Cross Bronx Expressway is officially completed, although related work continues until 1972.

1968

Construction of Co-op City begins. The complex was completed in 1971 and included 15,000 new apartments, many of them housing former residents of the Grand Concourse.

1970

The Concourse Plaza Hotel is transformed into welfare housing. Public protests caused the hotel to close; it was later reopened as senior citizen housing.

Diane Arbus (1923–1971) photographs Eddie Carmel in his parents' apartment on the Grand Concourse. The work, titled *A Jewish Giant at Home with His Parents,* is representative of Arbus's later work, in which she documented people considered outcasts by the mainstream.

1971

The Bronx Museum of the Arts opens at the atrium at the Bronx County Courthouse Building.

c. 1972

Gordon Matta-Clark creates a series of works entitled *Bronx Floors.* Matta-Clark (1943–1978) had been trained as an architect at Cornell University and later proposed an approach called *anarchictecture,* in which he illegally entered abandoned buildings and removed elements of their architecture with a chainsaw. Some of the pieces were displayed in galleries as sculptural objects; others were captured in still photographs or on film. *Bronx Floors* revealed the Bronx's colorful past while also providing evidence of its decay in the 1970s.

The Bronx-born photographer Alvin Baltrop (1948–2004) returns from service in the Vietnam War and starts documenting the New York piers near Christopher Street.

HÉLIO OITICICA

South Bronx Série VI, 1976
Digital slide projection and text
Courtesy of Projeto Hélio Oiticica

1973

Roosevelt Gardens is bought by the city to be turned into housing for senior citizens but is instead rehabilitated by the Krauss Organization for general residential use.

1975

Bronx Borough President Robert Abrams initiates a Sunday biking program along the Grand Concourse from 161st Street to Mosholu Parkway. The program, scheduled to be in effect from April through October, involved the closing of the center lanes to traffic. It remained popular through the tenure of Borough President Fernando Ferrer until it was discontinued by Mayor Rudolph Giuliani in the 1990s.

1976

The Brazilian conceptual artist Hélio Oiticica (1937–1980) visits the Bronx with videographer Martine Barrat, and makes the acquaintance of members of the Ghetto Brothers. Oiticica produces a series of 176 slides entitled *South Bronx Série VI,* some of which are submitted to the Brazilian magazine *Status.*

The Bronx County Historical Society restores the Edgar Allan Poe Cottage and reopens it for the public, operating it as a historic house museum for the New York City Department of Parks and Recreation.

1977

On July 13, a lightning strike at Buchanan South, an electrical substation on the Hudson River, shuts off two circuit breakers in Westchester County, causing a blackout throughout the Greater New York City area that results in citywide looting and other disorders, including arson.

On October 12, a fire starts in an abandoned elementary school a few blocks from Yankee Stadium shortly before the beginning of a game. The scene is captured by a helicopter-mounted camera, and Howard Cosell, who is narrating the baseball series for ABC-TV, intones, "There it is, ladies and gentlemen, the Bronx is burning."

1980

John Cassavetes releases *Gloria*, with his wife Gena Rowlands as a gang moll. The film's opening sequence follows a bus across the Macombs Dam Bridge through 161st Street, until it stops in front of the Concourse Plaza Hotel. By the time the film was being shot, the hotel had been abandoned for four years. The film's credits feature watercolors by the painter and collagist Romare Bearden (1914–1988).

1982

The Bronx Museum of the Arts moves to its current location on the Grand Concourse, at the corner of 165th Street, in the former synagogue of Young Israel.

1987

Bronx Borough President Fernando Ferrer; Luis R. Cancel, then Bronx Museum executive director; and Thomas K. Minter, Dean of Professional Studies at Lehman College, open the symposium entitled "The Grand Concourse: Its History, Architecture and Promise for the Future" (Bronx Museum of the Arts, June 6, 1987).

1992

Photographer Addison Thompson, recipient of a grant from the Graham Foundation, photographs art deco architecture in the Bronx. His project lasts until 1993.

1994

Loew's Paradise Theater closes to the public.

Faith Ringgold (b. 1930) completes a mural at Hostos Community College.

1997

The borough is named an "All-America City" by the National Civic League, in honor of the efforts of local community groups in the South Bronx to restore housing and other public services.

1998

Jorge Tacla (b. 1958) produces the mural *Memories of the Bronx* in Bronx Housing Court.

The Bronx-born artist Vito Acconci (b. 1940) designs the renovation of the subway station on 161st Street near Yankee Stadium, commissioned by the Metropolitan Transit Authority.

1999

The Lorelei Fountain in Joyce Kilmer Park is restored by the New York City Department of Parks and Recreation and moved to 161st Street and the Grand Concourse, close to its original site at 164th Street.

PIA LINDMAN

Fallow, 2000
Digital video, color, sound, 10:00 minutes
Courtesy of the artist

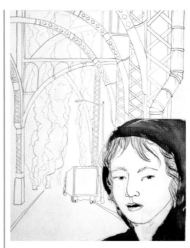

AARON BIRK

The Pollinator's Corridor—a graphic novel,
2003-2008
Sumi ink on handmade papers
(Mulberry, Kozo, Gampi, and rice)
Courtesy of the Artist

2002

The buildings housing the former Alexander's department store, at the Grand Concourse and Fordham Road, are restored by Fordham Associates, LLC, and reopened with a number of retail stores as well as educational facilities. Alexander's had closed in 1992.

2000

The Finnish artist Pia Lindman (b. 1965) creates a video about the replacement of the Lorelei Fountain. Titled *Fallow,* this work was specially created for the exhibition *Artists in the Marketplace: Twentieth Annual Exhibition,* and it documents a performance in which Lindman turned over the soil where the fountain had originally been situated. In agriculture, allowing land to lie fallow is a regular practice for aerating the ground and keeping it fertile. In her performance, Lindman implies that a cultural renewal is about to come to the area.

2003

The Philadelphia-based graphic artist Aaron Birk (b. 1978) spends a period in the Pelham Bay area working with ecologists and parks conservationists, learning about the local ecology. From his experiences there, he creates a graphic novel, *The Pollinator's Corridor,* centered on three teenage friends and their efforts to connect the coast of Hunter's Island with the cliffs of Inwood (the northernmost section of Manhattan) through a "genetic corridor" of native plants. Starting in December 2008, the novel is published in the *Philadelphia City Paper* in weekly episodes.

2005

The Bronx Museum of the Arts initiates the Grand Concourse Centennial Project with the goal of engaging the community in commemorating the concourse's centennial. The proposed series of annual programs includes panel discussions, charrettes, and walking tours.

Commissioned by the Public Art Fund, four sculptures by Alejandro Diaz (b. 1963), collectively titled *A Can for All Seasons,* are installed on the median strip of the Grand Concourse in front of the Executive Towers.

The Paradise Theater reopens after extensive renovation.

DANIEL HAUBEN

Bronx Vortex, 2008 (in progress)
Oil on canvas
Courtesy of the Artist

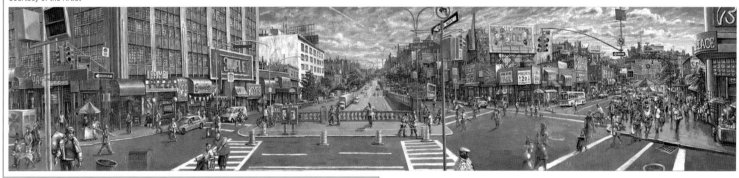

2006 | 2007 | 2008

Renovation work on ten blocks of the Grand Concourse, from 161st Street to 166th Street, starts in March. The work is completed in November 2008, approximately one year ahead of schedule.

The Parks Department commissions the interactive sculpture *Plinth, Monument, Stoop,* by George Sánchez-Calderón (b. 1967), for Joyce Kilmer Park.

The photographer and multimedia artist Xaviera Simmons (b. 1974) develops her project *Bronx as Studio* at Joyce Kilmer Park, a commission of the Public Art Fund in collaboration with The Bronx Museum of the Arts.

Nigerian artist Fatimah Tuggar (b. 1967) develops *Transient Transfer*, an interactive media project featuring several residents of the Grand Concourse. The project is a commission of the Public Art Fund in collaboration with the Bronx Museum of the Arts.

Daniel Hauben (b. 1956), who grew up in the Bronx, begins his five-panel painting *Bronx Vortex,* which depicts the intersection of Fordham Road and the Grand Concourse.

Front and back cover:
Jeff Chien-Hsing Liao, *The Grand Concourse and the Cross-Bronx Expressway*, 2008

Editor:Antonio Sergio Bessa
In-house Editor: Fredric Nachbaur
Art directors: Sergio Bregante & Joaquin Gallego
Graphic designer: Pablo Nanclares
Copyeditors: Vajra Kilgour and Eric Newman

This book accompanies the exhibition
Intersections: The Grand Concourse at 100
on view at The Bronx Museum of the Arts,
March 5, 2009, to January 4, 2010.

The staff for this project at The Bronx Museum of the Arts includes: Antonio Sergio Bessa, *Director of Programs*; Holly Block, *Executive Director*; Yvonne Garcia, *Director of Development*; Mary Heglar, *Executive Coordinator*; Alan Highet, *Director of Finance*; Lynn Pono, *Programs Manager*; Erin Riley-Lopez, *Associate Curator*; Alex Schneider, *Registrar*; Shirley Solomon, *Assistant Director of Development*; Kai Vierstra, *Preparator*; Camille Wanliss, *Director of Marketing*; Guy Willey, *Installation Designer*

The staff for the book at Fordham University Press includes: Fredric Nachbaur, *Director*; Mary-Lou Elias-Peña, *Assistant to the Director*; Kathleen O'Brien, *Marketing Manager*; Loomis Mayer, *Production and Design Manager*; Eric Newman, *Managing Editor*; Katie Sweeney, *Publishing Assistant*

Intersections: The Grand Concourse at 100 is made possible by the J. Ira and Nicki Harris Family Foundation; Council for Cultural Affairs, R.O.C., in collaboration with Taipei Cultural Center of TECO in New York; Graham Foundation for Advanced Studies in the Fine Arts; National Endowment for the Humanities; Paul and Klara Porzelt Foundation; U.S. Institute of Museum and Library Services; New York State Council on the Arts, a State Agency; Kodak; and Jane Wesman and Don Savelson. Katie Holten's *Tree Museum* was created with support from The Greenwall Foundation's Oscar M. Ruebhausen Commission. The first Lobby Project Series by Vito Acconci is generously supported by the Starry Night Fund of Tides Foundation and Dolan & Traynor / DuPont Corian®

The Bronx Museum of the Arts receives ongoing general operating support from the New York City Department of Cultural Affairs with the cooperation of the Bronx Borough President and the Bronx Delegation of the New York City Council; Ford Foundation; Starry Night Fund of Tides Foundation; New York State Council on the Arts, a State Agency; the Bronx Delegation of the New York State Assembly; New York Times Company Foundation; and private sources.

Fordham University Press was established in 1907 to represent and uphold the values and traditions of the University itself and to further those values and traditions through the dissemination of scholarly research and ideas. The Press focuses primarily in the humanities and the social sciences, and publishes books focusing on the metropolitan New York region and books of interest to the general public.

The Bronx Museum of the Arts is the sole visual arts museum in the Bronx, founded in 1971 as a twentieth-century and contemporary art museum, to serve the populations of the Bronx and the New York metropolitan area. It has a longstanding commitment to increasing and stimulating audience participation in the visual arts through its permanent collection, special exhibitions, and education programs.